Wilmington

HARRY ROGERSON

Wilmington

Picturing Change

THE
History
PRESS

Published by The History Press
Charleston, SC 29403
www.historypress.net

Cover design by Marshall Hudson. *Photo courtesy of Carman Panaro.*

Unless otherwise specified, all photographs in this book are from the private collections of George Latimer Rogerson Jr. and Harry Albert Rogerson Jr.

First published 2008
Second printing 2015

Manufactured in the United States

ISBN 978.1.59629.457.8

Library of Congress Cataloging-in-Publication Data

Rogerson, Harry.
Wilmington : picturing change / Harry Rogerson.
p. cm.
ISBN 978-1-59629-457-8
1. Wilmington (Del.)--History--20th century--Pictorial works. 2. Wilmington (Del.)--Pictorial works. 3. Repeat photography--Delaware--Wilmington. 4. Historic buildings--Delaware--Wilmington--Pictorial works. 5. Wilmington (Del.)--Buildings, structures, etc.--Pictorial works. I. Title.
F174.W743R64 2008
975.1'20430222--dc22
2008014873

Notice: The information in this book is true and complete to the best of our knowledge. It is offered without guarantee on the part of the author or The History Press. The author and The History Press disclaim all liability in connection with the use of this book.

To my wife, Elizabeth,
who first encouraged me
to write this book years ago.

CONTENTS

FOREWORD

I have looked forward to this book ever since Harry Rogerson told me of his plans to publish it. When he asked me to write the book's introduction, I was thrilled at the opportunity, never having done anything like this before. We later joked that we were both going into uncharted territory—his first book, my first introduction. But that is what makes life interesting.

The book you are holding is much more than just a book; think of it as a passport, one that allows you to revisit Wilmington the way it used to be. Not only will you see it the way it *was*, but you will be able to compare those memories with more recent photographs. All of this is possible because of the camera, which I believe is one of mankind's greatest inventions. To be able to look through a viewfinder, frame the picture you want and then press a button to capture a moment in time, forever—that, to me, is pure magic.

All of us have hundreds, maybe thousands, of photographs that we have taken over the years. Some are in boxes, many have been lovingly placed in family albums but the majority are probably still in the original envelopes they came in, from the drugstore or the photo shop. How many times have you said, "I've got to get those snapshots organized some day." Harry Rogerson has done it, and he's done it in a very appealing way. He has culled some of the best photos from his vast collection and turned them into a nostalgic slide show—one that you, the reader, controls. This gives you time to pause and study each photo, to let it sink in, to have it trigger memories—and, let's face it, we all have many memories inscribed on every page of this book. Noted author Depak Chopra once commented on why we enjoy holding a book in our lap. Books never rush you; they give you, in his words, "time to reflect."

As I looked at some of the scenes of Market Street, I recalled my first job in Wilmington, at the S.S. Kresge five-and-ten-cent store. I was eighteen and working as a stock boy. (I had jokingly told my friends back in Pennsylvania that I was in *Summer Stock*—and I was, tons of it.) Harry's Market Street photos brought back a vivid memory of seeing presidential candidate Wendell Willkie and his campaign motorcade slowly wend its way down our main street. Thousands had turned out to wave at the man who would be president. I had gone to the second floor of the five-and-ten to get a better view and had to stick my head out of a very small window to see the spectacle. Talk about excitement!

There are so many other scenes and places that all of us can remember—all those theatres we once had downtown. Wouldn't you love to once again visit the Warner Theatre on Tenth Street, to sit in that ornate lobby or see those magnificent curtains part as you settled back to watch Myrna Loy, Kay Francis or Spencer Tracy?

I think it is safe to predict that this book might also be used to settle some friendly arguments: Farmer's Bank, was it at Tenth and Market or Eleventh and Market? Was it Delaware's Farmer's Bank or just Farmer's Bank? "Get the book!" someone will shout, and the question will be answered.

Thousands have visited Harry's website, OldWilmington.net, but he has done us all a big favor by publishing many of his best photos in this collection of images.

Many thanks to Harry Rogerson for his unflagging interest in compiling this pictorial review of Wilmington. It will stand as a book of record for years to come.

Richard B. (Dick) Holmes
Dick Holmes is a popular Wilmington-area radio personality

ACKNOWLEDGEMENTS

My uncle, George Rogerson, whose collection represents the majority of the "then" photographs, and the photographs of Norman Buckalew, Jim Horty, Rosemary Culver and Christine Spinazzola Gale are the principal reason for publishing this book. Without their photographs, this work would not have been possible.

Additionally, George's daughter, Nancy L. (Rogerson) Peterson, offers the following:

George Latimer Rogerson Jr. was born February 14, 1917, and was raised in Wilmington, Delaware. He attended schools in the Wilmington area and was a 1936 graduate from Wilmington High School. After graduation, he worked for Railway Express Agency and the Pusey and Jones Corporation before moving on to Westinghouse Electric and the DuPont Company. He was a sheet metal fabricator by trade and retired from the DuPont Experimental Station in 1981.

George enjoyed many hobbies, including oil and water color painting, wood carving (winning several awards), coin and stamp collecting and photography. He combined his interest of the history of Wilmington and surrounding area and his hobby of photography by taking before and after pictures documenting the changes in the Wilmington area. George and his wife Margaret would put on slide show presentations for various groups and seniors' homes of their trips overseas and the before and after Wilmington pictures.

George passed away in June 1992, one year after his wife Margaret. His pictures are presented here in his memory. Unfortunately, this is only a sampling, as most of the pictures were lost after his death. I am sure that my father would be proud to know that some of his pictures live on for others to enjoy.

INTRODUCTION

When we read words referencing "then" and "now," describing the objective of a book as comparison, we generally think of "then" as the distant past—the times gone by, such as the early part of the 1900s through the 1930s. However, the city of Wilmington, while going through changes in those times, made more significant changes in the recent past—the 1950s and forward—changes that people from the 1920s and 1930s could not have imagined.

Who would have imagined:

- That "Good Old Wilmington High School," the school from which most of Wilmington's children graduated, would close in 1960 and be demolished soon afterward; Brown Vocational High School would disappear in the 1980s and the site would be transformed into a park; and the PS DuPont High School would become an elementary school.
- A four-lane freeway going right through established Wilmington neighborhoods or the clearing of houses and business on the east side of the city as part of an urban renewal project.
- Market Street without automobile traffic, movie theatres or the Dry Goods.
- Wilmington becoming a boomtown for the banking industry and constructing its high-rise buildings.

The changes were also beneficial:

- They brought about the elimination of the tanneries with their unpleasant odors along Madison Street and Maryland Avenue and the development of the Christiana Riverfront, the Riverwalk, a new baseball stadium and the rebirth of the Wilmington Blue Rocks baseball team when the old shipyards were demolished.
- Renovation of the old, vacant and decaying businesses along Market Street with the creation of new and fresh apartment buildings.

However, in addition to the changes that we can actually see, there are the changes that most of us will always see through our mind's eye:

- The many movie theatres that were located in the city, the neighborhood cellar stores, the Bancroft Mill Store, the *Sunday Star* newspaper, Wilmington Sash & Door Co., the Broom Man, Mr. Peanut and the trackless trolley cars.
- Traveling out Concord Pike to Lynthwaite Farm for ice cream or North Market Street to Penny Hill for donuts.
- Taking a sightseeing cruise on the Wilson Line or going to New Jersey on the ferry.

The changes taking place today will be tomorrow's remembrances. And, throughout all of the changes, Wilmington's old neighborhoods still remain: Browntown, Forty Acres, Little Italy and Quaker Hill, to name a few.

Already, there is a new neighborhood created due to the improvements. Christina Landing, an area of development on South Market Street, was turned into a residential area with townhouses, apartments and a high-rise tower. Until now, this district was the location of junkyards, auto-body repair shops, vacant and rundown buildings and undeveloped sites.

The "then" photos, together with my collection representing the "now" photographs, will tell a story of a city in transformation. We will take a journey, beginning with a trip up Market Street and then moving to the city blocks just off of Market Street. After a brief view of the changes that took place around the city, we will return to view the revitalization that is in progress or has already been accomplished.

Downtown Market Street

Wilmington, Delaware, is not unlike any other mid–Atlantic Coast city. It saw its way through the Industrial Revolution and the Depression. By the 1940s, the industries that came into being were running at full capacity—shipbuilders, leather tanners, railroad car fabricators and chemical and automobile manufacturers were just a few. During World War II, several of them were called upon to supply the U.S. military with tanks and war-support ships.

To support these industries, employees came from every corner of the city. Wilmington was already a diverse city of neighborhoods made up of families from various ethnic and religious backgrounds and affluence. Each neighborhood had its supply of "corner" and "cellar" stores, above which the owners usually lived. Every youngster knew where to purchase penny sweets, while their parents relied on the neighborhood stores for everything from fabric bluing to toothpaste.

Pharmacies, butchers and bakers were not left out—many were within walking distance of residents' homes. The pharmacies and drugstores had large, chemistry-type containers filled with colored liquid in their show windows. The pharmacists had to "compound" prescriptions from larger drug bottles following the doctors' prescriptions. The butchers cut and weighed the meats to the customers' requests, and the neighborhood bakers would cut their bread while it was still warm and the aroma would linger in the air.

The larger bakeries and dairies provided door-to-door products. Their trucks traveled the city streets, making deliveries to both homes and businesses. The icemen and the coalmen all made their scheduled rounds. There were also the individual merchants who trekked from neighborhood to neighborhood, some with horse-drawn carts, selling their wares or services, which included sharpening scissors, collecting old rags and photographing children on a pony.

The neighborhood businesses served the residents in their everyday needs, but the time arrived when they had to go downtown to do major shopping. While that meant purchasing clothes, furniture, linens or toys, many did not have automobiles and relied on public transportation. A short walk to the nearest trolley car or bus stop was a satisfying way to get to downtown.

Once there, everything was at hand. In today's terms, Market Street was the "hub" and Wilmington Dry Goods was the "anchor" store. From its location at Fourth and Market

Streets to six blocks north at Tenth Street, everything could be found. The large furniture stores were located even a block or two east or west of Market Street, along with hobby stores and fruit and vegetable dealers.

Every block had at least two restaurants or soda fountains. Specialty stores providing millinery, shoes, fabrics, jewelry, hosiery and haberdashery were present. Movie theatres also occupied Market Street, showing everything from first-run films to cartoons, news, B-films, serials and previews of the coming attractions.

On Saturdays, farmers from the surrounding area would arrive just one block east of Market Street. King Street, the second major retail area in Wilmington, provided spaces for the farmers to back their trucks into their assigned areas to sell live chickens, eggs and an assortment of locally grown vegetables.

Several times a year, special sales were held, especially at the Wilmington Dry Goods. And when it had a sale, the other stores would follow. The Dry Goods, as it was called, took out multiple full-page advertisements in the local newspaper. It would open extra early, but no one was allowed in until after the playing of the national anthem. Then, when the doors were opened, the mad rush was on as customers headed to the department of their choice for the items on sale. In 1960, I had the opportunity to work in the curtain department selling Venetian blinds and awnings. For eighteen months, I was the one to open the King Street door. Every day I witnessed the activities of delivery trucks and traffic, while the aroma from the roasting peanuts on Fourth and King Streets filled the air.

Meanwhile, on Market Street, two-way automobile traffic was just as busy as the pedestrian traffic. Policemen directed traffic at the major intersections, especially where the trolley cars would make their turns. Mr. Peanut could be seen walking up and down Market Street, and the store windows and showrooms displayed their products in the same manner as—or even superior to—larger cities elsewhere.

Shoppers had special places where they would meet friends: under the bank clock at Sixth and Market Streets, the lunch counter of their favorite five-and-dime or the notions table at the Dry Goods. There were shoppers who would transfer to the Wanamaker's bus to venture out to the John Wanamaker's Augustine Cut-Off store, which opened in 1950, to shop and have lunch in the tearoom. This was perhaps an extension of Market Street at the time, but it may have been the foretelling of things to come.

Market Street had its share of banks, and the DuPont Company's corporate headquarters was located at Tenth and Market Streets. Market Street also had its less desirable area as well. The three blocks south of Fourth Street were the locations of the pawn dealers, warehouses and storage buildings, as well as an "art" movie theatre.

But, like everything else, it all started to come to an end in the late sixties. The Sears & Roebuck store had relocated to a new store on North Market Street in 1950. Shopping centers were cropping up in the suburbs, and housing developments began to overtake the few incorporated towns, farmlands and wooded areas. The city population was shifting, and some of the Market Street stores expanded to the suburbs. This included the Dry Goods, which opened three stores in suburban shopping centers. Then, in 1968 and 1978, the Concord and Christiana Malls opened, respectively.

The shipbuilders, leather tanners and railroad car fabricators had already closed or were about to close. Workers were looking to the suburbs for employment. Over twenty square

blocks of housing, businesses and churches were being demolished to make way for the Adams–Jackson Street Freeway, later to be designated as Interstate 95.

In 1968, following the assassination of Dr. Martin Luther King Jr., whole city blocks were ravaged by looting and fires. The National Guard remained on duty on street corners for almost a year.

By the seventies, Market Street lost its charm. The stores were gone, the sales were gone and the shoppers were gone. The Dry Goods store on Market Street closed its doors in 1974. The city government tried a pedestrian-style mall concept in 1975 by eliminating automobile traffic on Market Street to lure back the shoppers. Even a portion of West Ninth Street was turned into the Ninth Street shops. The last of the larger stores on Market Street closed in the mid-1980s. As of the writing of this book, the pedestrian mall concept was abandoned and automobile traffic was allowed to return. A complete overhaul was beginning to take place to return the charm to Market Street.

The following photographs chronicle contrasting views of what was once old Wilmington.

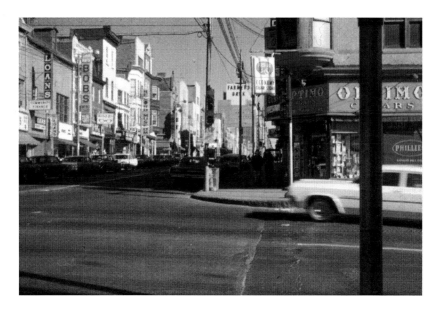

The intersection of Fourth and Market Streets was the beginning of the main shopping area. It was also one of the locations for making bus transfers to other parts of the city and the suburbs. Between here and Tenth Streets, stores selling every thing imaginable could be found. Pedestrians making their way from shop to shop at times would be shoulder to shoulder. Market Street was also wide enough for two-way traffic and curbside parking. There were movie theatres, restaurants and five-and-dime stores with old-fashioned soda fountains.

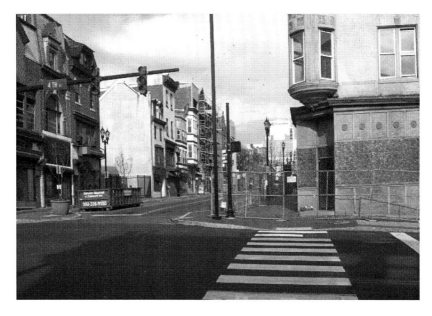

Market Street soon fell victim to the expansion and development of the suburban shopping centers and indoor malls. Like the area below Fourth Street, businesses vacated the buildings and they, too, fell into disrepair, with many stores being boarded up or demolished. Today, the Fourth and Market Street region is under redevelopment.

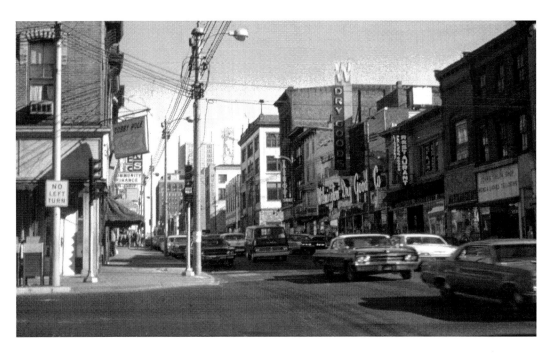

Fourth and Market Street was the location of the Wilmington Dry Goods Company. In today's terms, it was the "anchor" store. The store had squeaky wood floors and wooden merchandise tables. The pricing signs were hand painted in the store's own sign shop. Shoppers could find anything from clothing, curtains, hardware, toys and rugs, to cut meats, fig bars, phonograph records and watch and shoe repair services. When special sales were held, large crowds would gather at the doors, waiting to enter.

Rx dept. (De Big Acct.)

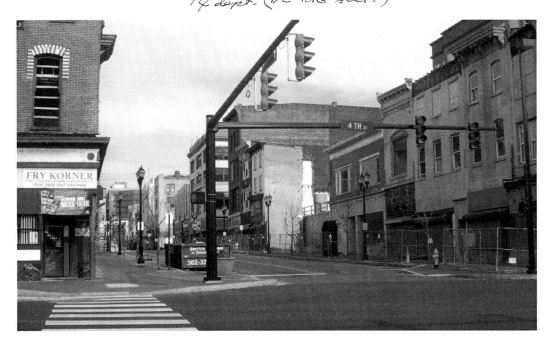

The Dry Goods, as it was often called, later opened several stores in the suburbs. The Market Street store closed in 1974 and later fell to the bulldozers. Once that happened, the other stores began to close and the buildings sat unoccupied for many years. Pedestrian traffic started dwindling as a few businesses tried to survive.

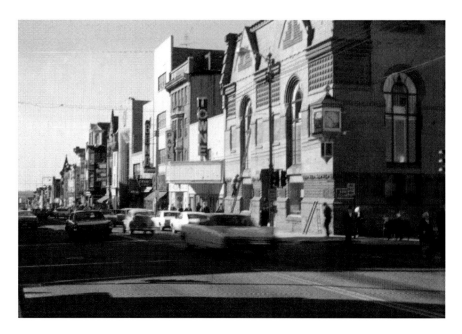

Moving up to the area around Sixth and Market Streets, you would find the location of the Bank of Delaware and its well-known clock. We can see from this 1969 photograph that the Towne Theatre, a few doors down, had already closed. During this time, Market Street was still open to vehicular traffic, but the shopping public was thinning out.

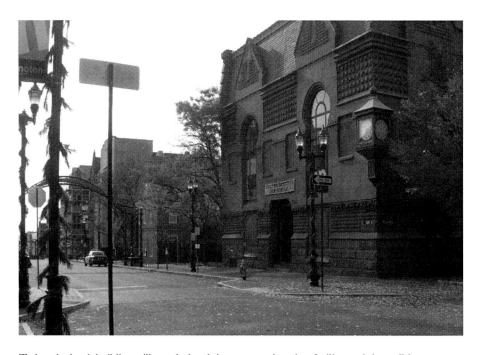

Today, the bank building still stands, but it is now an education facility, and the well-known clock has lost its hands. The Towne Movie Theatre was demolished many years ago, making way for the development of Willington Square Park as part of the Historical Society of Delaware complex. Another bank building on this block, the former Artisans Savings Bank, is now occupied by the historical society for housing its documents and research area.

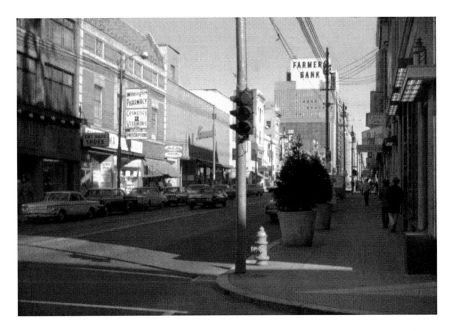

Continuing north on Market Street at Sixth Street, the Farmers Bank building stands out in the distance and the Kennard-Pyle Department Store is on the left. On the immediate right-hand corner is the former Delaware Power and Light Company building. On its roof was the "Redi-Kilowatt" sign. This 1969 photo shows a few early morning shoppers making their way up Market Street.

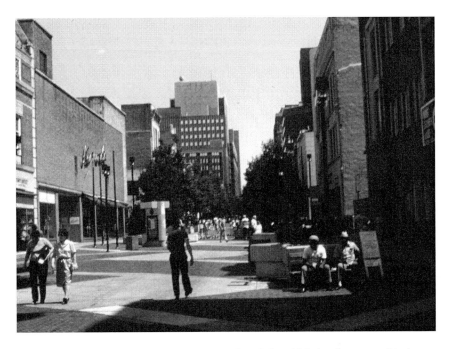

In 1975, the city created a pedestrian-style mall and closed Market Street to vehicular traffic. Trees, benches, large flower pots and a fountain were created as a means to lure shoppers back to the downtown area. Many of the businesses balked at the idea of eliminating automobile traffic, insisting that no traffic meant no shoppers. Banks were beginning to make changes also, as observed by the missing Farmers Bank sign.

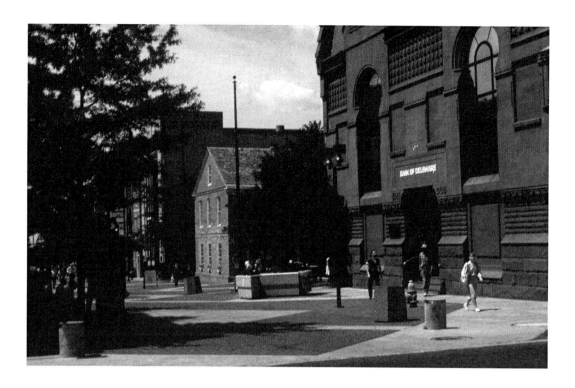

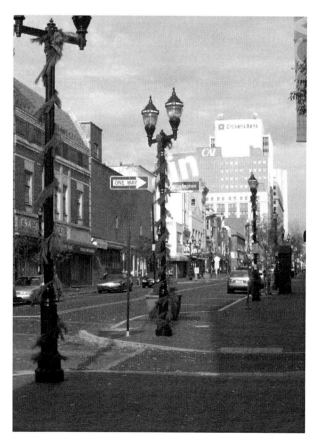

Above: This 1984 photo illustrates the pedestrian mall in front of the Bank of Delaware building at Sixth Street. A few shoppers are present, but not to the extent of two decades earlier. The trees were also planted as part of the pedestrian mall expansion.

Left: The Farmers Bank became Citizens Bank, and the Kennard Department Store closed. The idea of the pedestrian mall was abandoned and automobile traffic returned, but the traffic was not as active as it had been decades earlier. Urban renewal began to take shape, and as stores vacated, so did the shoppers. A few of the merchants relocated to the suburban shopping centers and indoor malls, but many just closed their doors. In some of their vacated locations, newer stores emerged, but these too eventually folded. Only a few managed to survive, including several restaurants. Today, as the city and Market Street try to regain their charm, major redevelopment is already planned. Investors are buying up groups of buildings to breathe new life into the empty structures. In the near future, Market Street may once again reemerge as the heart of Wilmington.

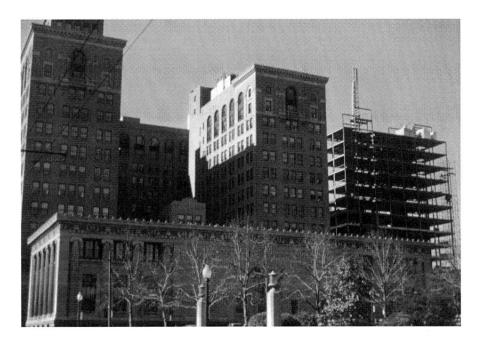

One of the most extraordinary building projects to occur on Market Street was the construction of a tower inserted into the existing U-shaped Delaware Trust building on the left. The original building was built in 1921, and the two fourteen-story wings were built in 1930. The Bank of Delaware, under construction on the right, began in the late 1950s. That building was topped off with a Delaware-shaped structure.

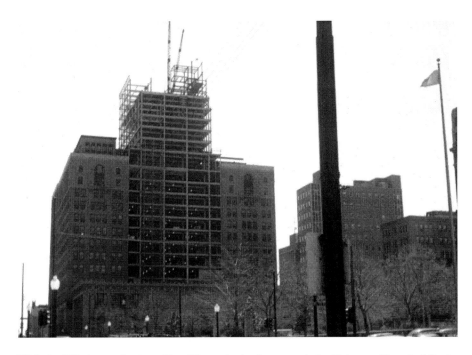

With the Wilmington Institute Free Library in the foreground, the Delaware Trust building's twenty-two-story tower was constructed in the 1970s between the two existing structures. The building housed the main offices for the Hercules Company, which would later construct its own building just four blocks north.

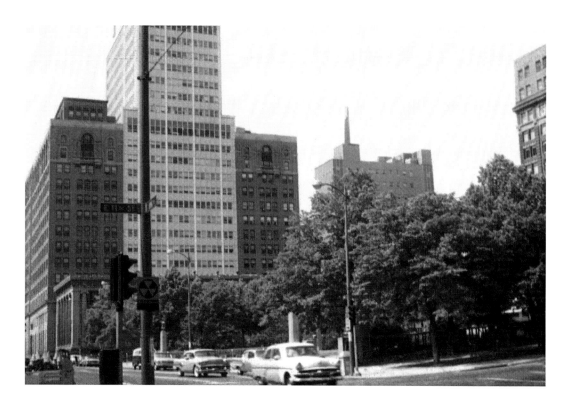

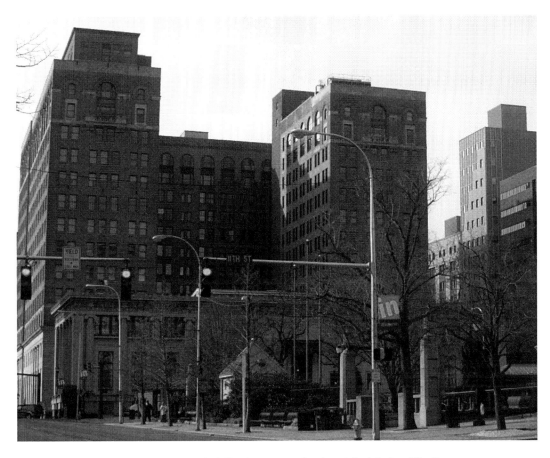

With the renovation now complete, the building has returned to its original design. The fourteen-story Residences at Rodney Square, as it is now known, features over 270 apartments with retail space on the first floor. The vault rooms were left intact and converted into workout rooms. The vaults at one time were said to house gold bullion.

Opposite above: The Delaware Trust tower stands nearly complete in this 1970s photograph. The Bank of Delaware building is on the right. Both buildings occupied each side of the 900 block of Market Street. Delaware has bank-friendly laws. These laws would later attract other banks that would construct buildings both north and west of Tenth and Market Streets and in the area near the lower end of Market Street. Once the tower was complete, the building became an easily recognizable structure in the city. (As this has now been noted, it will be used as a reference point in the next chapter.)

Opposite below: In April 1997, a major fire damaged the Delaware Trust building and it stood vacant for six years. In 2002, the building was sold and the new owners prepared to remove the twenty-two-story tower in 2004, as seen by the crane positioned to the right of the building. The owners planned to convert the building into an upscale apartment complex.

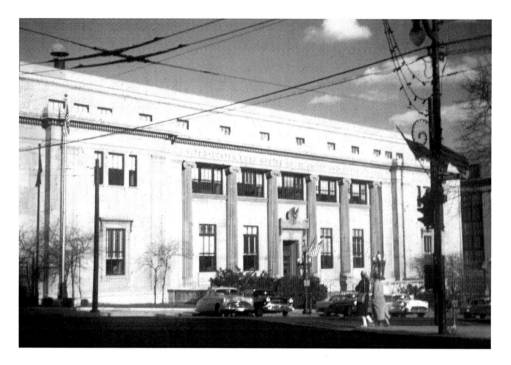

Just another block north on Market Street at Eleventh Street, facing Rodney Square, is the United States Post Office building, built in 1937, serving the city as its main operations center. The overhead trackless trolley car wires are clearly visible in this 1950s photograph. The overhead wires were removed as trolley car service ended in March 1958.

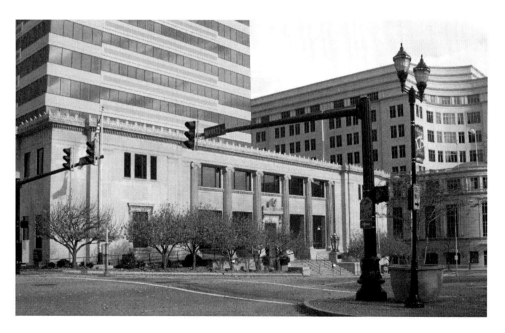

The U.S. Postal Service vacated the building in the 1980s. The Wilmington Trust Company purchased the building and constructed a tower through the center of the building, thus keeping the neoclassical façade. Also visible on the right, at Eleventh and King Streets, is the MBNA Bank building. Prior to that, it was the location of the Continental American Life Insurance Company. Today, the building is the home of the Bank of America.

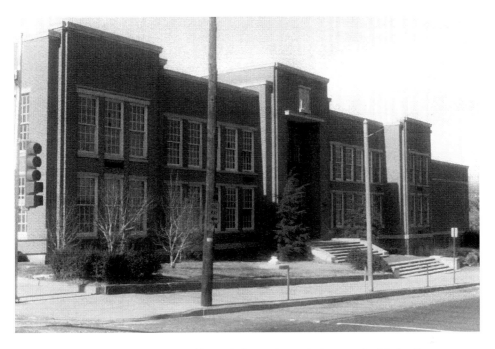

After Market Street crests a hill above Eleventh Street, it travels down to the Market Street Bridge, crossing the Brandywine Creek. This point is the end of the major business district. At Fourteenth Street was the H. Fletcher Brown Vocational High School. Named to honor chemist and philanthropist Harry Fletcher Brown, the school was dedicated in 1938. The school building was demolished in 1980. *Photo courtesy of Norman Buckalew.*

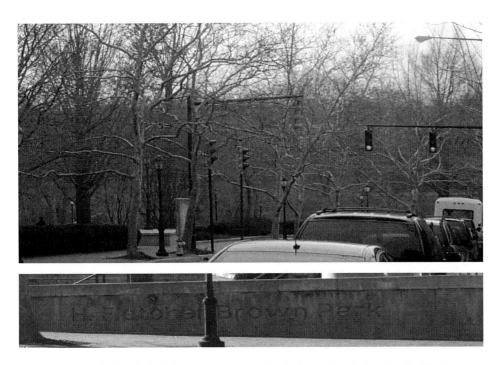

The school's curriculum included courses in the mechanical and electrical trades. H. Fletcher Brown Park now occupies the ground where the high school once stood. Erected in the park is a statue depicting an engineering apprentice.

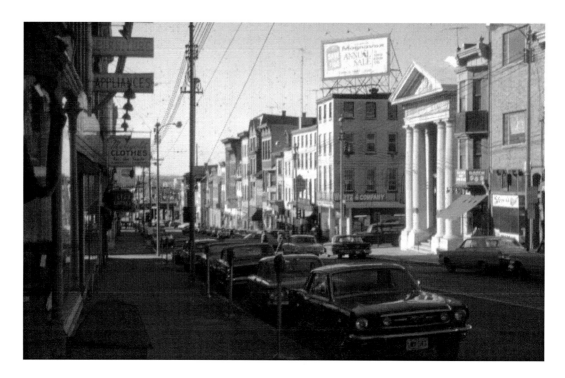

The columned Farmer's Bank of Delaware building on Third Street was one of a few major businesses that were located on Market Street below Fourth Street. Other businesses included those selling wallpaper, paint, cash registers, shoes and clothing, in addition to pawnshops, an art movie theatre, wholesalers and storage buildings. Most of the buildings were in bad condition and the district was not generally regarded as a major shopping area.

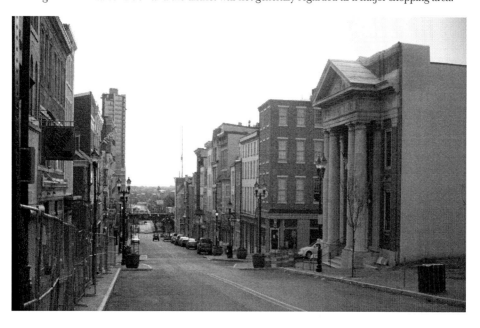

By the 1980s, what little pedestrian traffic there was had disappeared, most of the businesses had closed and the century-old buildings were abandoned and neglected. Today, after years of planning and redevelopment, a six-block area below Fourth Street has been given new life. The creation of the Ships Tavern District, named after an old tavern going back to George Washington's time, will include small shops, upscale restaurants and loft-style apartments.

AROUND TOWN

After months and years of neighborhood meetings, protests and demonstrations in the late 1950s and early 1960s, signs of old Wilmington began disappearing with the planning of the Adams–Jackson Street Freeway, a designation given to the new Interstate 95, and the area chosen for its route. As the new road entered the city from the south, it would parallel the northeast corridor of the then Penn Central Railroad mainline. After passing adjacent to the Dravo Ship Building confines and the two Delaware Power and Light gas storage tanks, the road construction crossed over the railroad and cut through an industrial area. Then, it began its trek between Adams and Jackson Streets following all of the number streets to Eleventh Street. At that point, it went under Delaware Avenue and headed toward a new bridge over the Brandywine Creek. In its path were row homes, small businesses, churches, a movie theatre and a brewery. The interstate was not fully constructed until the early 1970s. Until then, segments were opened for traffic. This minimized the through traffic on the city streets and allowed easier access to the downtown area.

Although Market Street was considered to be the heart of Wilmington, there were other avenues for shopping—mainly King, French and Walnut Streets to the east and Shipley, Orange and Tatnall Streets to the west. The number streets from First Street—or Front Street, as it is identified—up to the vicinity around Twelfth Street were the location of other specialty retailers for shopping, but this also was the region for small business offices, wholesalers and residential buildings.

This entire area has undergone extensive redevelopment. Entire blocks of vacant and neglected businesses, apartments and houses were demolished. Once cleared, a few of the sites were used for automobile parking lots until construction started. Governmental buildings began to emerge in the 1980s. Later, insurance company, motel and bank buildings were constructed.

To go along with the building construction, city streets were modernized as well. A new major highway was built to connect downtown with Interstate 95. Front Street was widened and redesignated as M.L. King Boulevard. A four-block section of French Street above Fourth Street was closed off, in addition to a two-block section below Fourth Street. Planning of new parks and new housing for city residents was long overdue. All of this new construction was, without reservation, also removing the old Wilmington that once existed.

In the 1990s, high-rise bank buildings were constructed in the area below Fourth Street between King and Walnut Streets. Also, the vicinity along both Tenth Street and Delaware Avenue was presented with high-rise bank buildings in the 2000s. Wilmington finally joined with other cities to say that it, too, had its share of skyscrapers. Up until then, there were just the four or five buildings around the Rodney Square District that could be called skyscrapers.

This modernizing of Wilmington did not stop in the center of the city. More important, perhaps, was the redevelopment of the portion of the city south of Front Street. This was a segment of the city that once was home to the shipbuilders, railroad facilities, a newspaper publisher, machine shops and other media to heavy industries. Much of the development meant clearing most of those old and rundown facilities.

From that, a new ballpark and shopping area were born. Several restaurants, a convention center and a new microbrewery were introduced. A paved and boarded walkway following the Christiana River shoreline allows visitors to walk from the Riverfront shops to the Amtrak station, passing the preserved old shipbuilding industry's brightly painted cranes. Landscaping to blend in with the surrounding Christiana River was also accomplished.

To begin our then-and-now comparison, we will commence from the construction of Interstate 95 and follow it up to the Brandywine Creek Bridge. Then we will move over to the Market Street Bridge and travel down to Front Street, crossing Market Street east and west on our way.

The east side urban renewal project was the beginning of Wilmington's expansion and improvement. The planning and the clearing of whole city blocks began decades ago. Vacant and dilapidated houses and businesses were demolished. Some of the vacant city blocks were turned into parking lots to handle the workers of the downtown businesses.

As the new buildings were constructed, most would contain their own underground parking facilities. The new buildings would include facilities for the federal and local government, insurance companies, a motel and banks.

Each of the new buildings would create much-needed jobs. But that also meant that new housing would be required as well. That need was met by the renovation of several office buildings that became vacant as a result of the newer construction. One such building was marked for demolition after a damaging fire, but it was saved after developers planned to turn it into apartments.

This type of thinking and long-range planning was soon to become the turning point for a city in distress. But not all plans followed a smooth transition. Several entrepreneurs opened their restaurants, only to close them a few years later. Banks also made the road bumpy for the city as mergers took place.

As a result of the city renewal projects, two hospitals were raised, as well as homes, businesses, churches and movie theatres. The photos that follow continue the story of Wilmington, then and now.

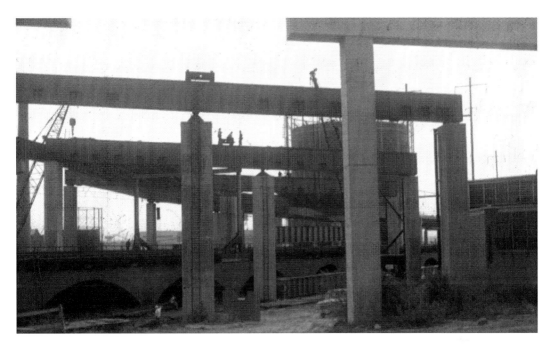

Our journey through the city begins with the construction of the Adams–Jackson Freeway, as to which it was referred in the early stages. This 1965 photo illustrates the progress of the I-95 viaduct construction as it passes over the northeast railroad corridor. One of the Delaware Power and Light Company's huge gas storage tanks is visible in the background. This section of the city was also the location of many business, including several tanneries, which were demolished.

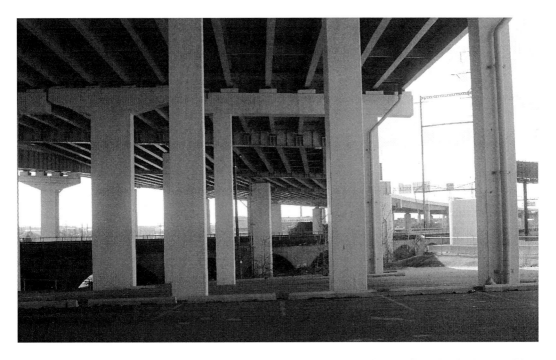

The viaduct substructure carrying I-95 today makes a wide curve as it heads south from the city. I-95, at this point, is heavily traveled by commuters and vacationers alike. The first exit to the city, Maryland Avenue, is at the far left.

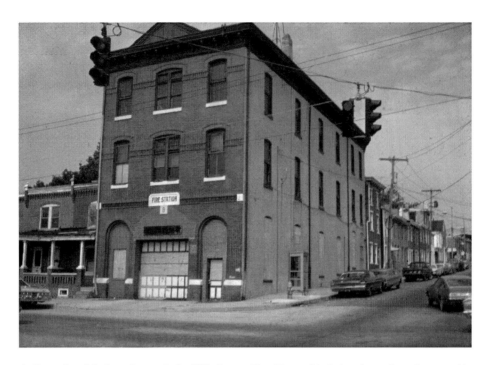

At Second and Jackson Streets is the Wilmington Fire House #8. Being situated on the west side of Jackson Street, where the freeway construction was underway, it was spared demolition. In this 1977 photo, the city fire department had vacated the building.

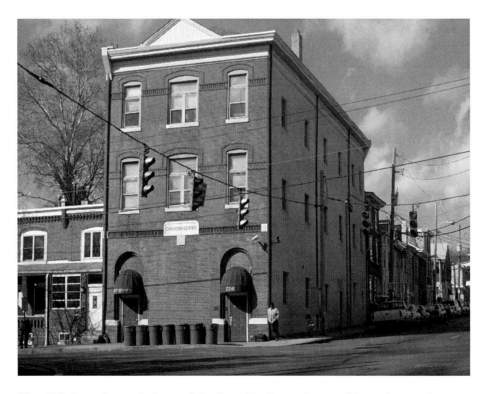

The old firehouse is now the home of the Capuchin Center. As part of its services, meals are served to the needy on a regular basis.

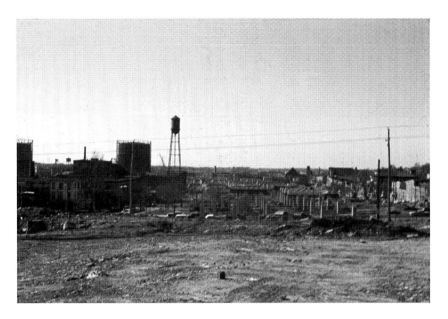

Making its way between Adams and Jackson Streets in this 1965 photo, taken from the vacant block between Fifth and Sixth Streets looking south, many concrete columns stand, waiting for the steelwork to begin. At this point, the new road will proceed below grade. A brewery once occupied this location. In the distance are the two Delaware Power and Light gas storage tanks and the water tower for the Amalgamated Leather Co.

Today, it would be impracticable and unsafe to duplicate the previous photo. The road at this position enters the viaduct at Fourth Street, toward the Maryland Avenue exit, and then continues south. From this point north, the original grade was the same height as the point at which this photo was taken. The excavation from here to above Delaware Avenue was far below the basements of the homes that once stood in the path of the freeway.

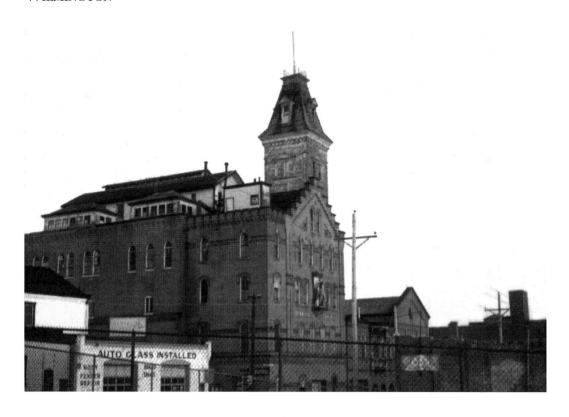

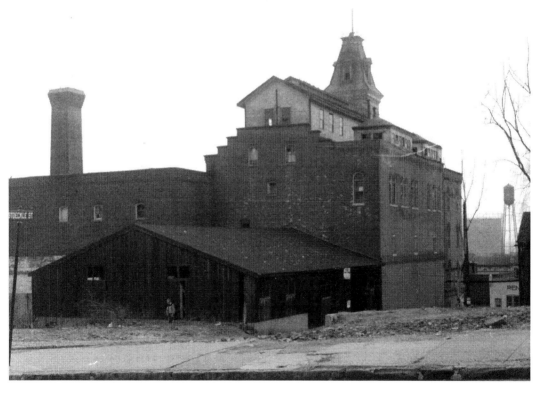

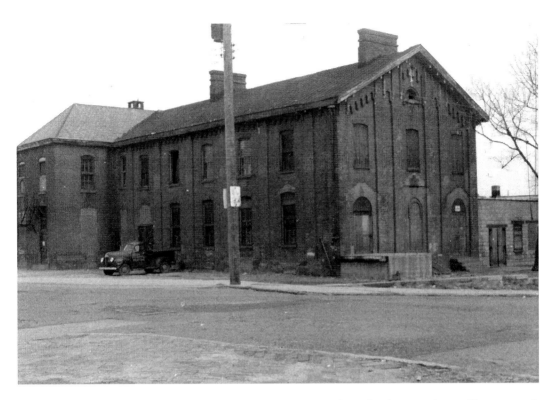

From 1955 until its buildings were demolished, the brewery was used as a furniture warehouse. *Photo courtesy of Norman Buckalew.*

Opposite above: At Fifth Street between Adams and Jackson Streets, the former Stoeckle Brewery buildings were still standing in 1962, not yet demolished by the wrecking ball. Built in the late 1800s, the buildings served as a brewery until 1955. The King Gambrinus statue is visible, perched on the third-story wall. The statue was rescued and later erected in front of a restaurant north of Wilmington.

Opposite below: The rear of the brewery was located on Sixth Street. The block-long Stoeckle Street sign is visible on the left. Stoeckle, and later the Diamond State Brewery, provided Wilmington with its own locally brewed beer. *Photo courtesy of Norman Buckalew.*

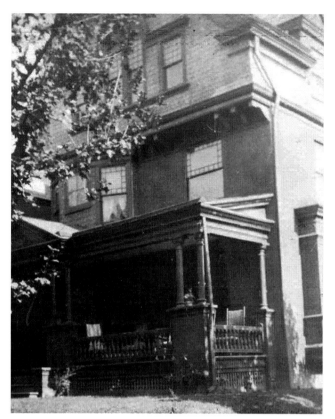

Left: This home, located at 1100 Jackson Street with stained-glass windows, is indicative of the type of homes that once flourished in the neighborhood. This home and hundreds like it, along with apartment buildings, churches and a movie theatre encompassing over twenty square blocks, were all in the path of Interstate 95. The displacement of the established families was a painful event for the city. *Photo courtesy of Jim Horty.*

Below: Again, looking south in the area of Eleventh Street, a stoop of someone's home is all that remains. Once the excavation was completed, a clear view to the south made it possible to see the large gas storage tanks until they were removed. The construction in this area was excavated far below the adjacent streets on each side.

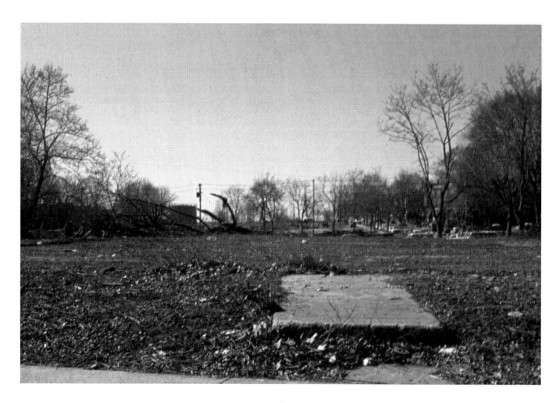

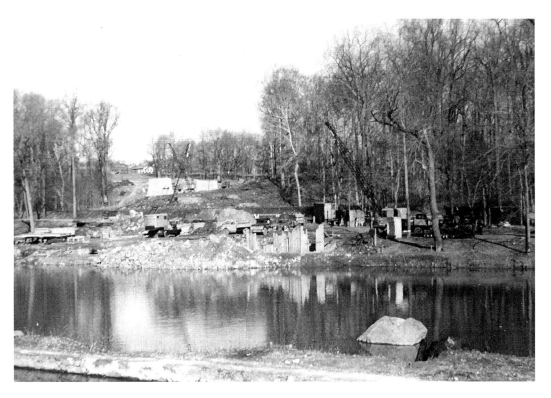

Pilings are placed for the supports as construction begins where the I-95 bridge crosses over the Brandywine Creek. Once over the bridge, the road returns to grade level as it travels north of the city. *Photo courtesy of Norman Buckalew.*

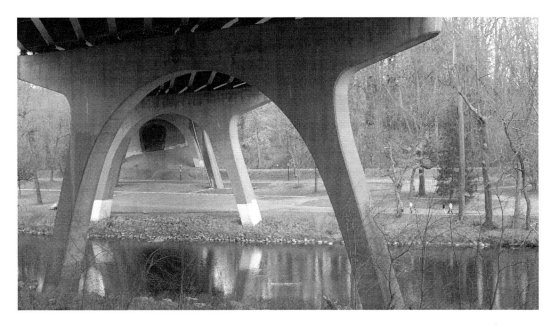

Today, the completed six-lane bridge spans the Brandywine Creek and carries the majority of traffic entering the city from the north. The bridge construction over the Brandywine Creek and Park below at this point was a concern for the historical area. However, pictures to appear in a later chapter will indicate how the bridge blends in with the natural surroundings.

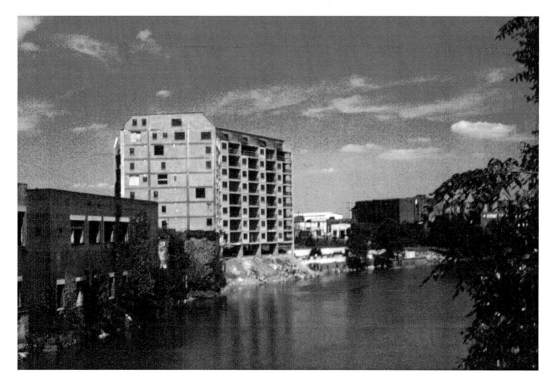

Moving east to Market Street, this apartment building is under construction, as viewed from the Market Street Bridge in the 1980s.

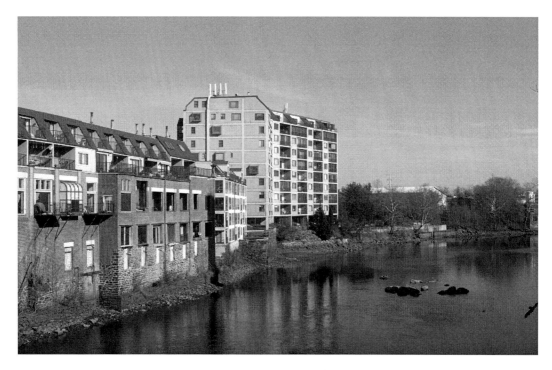

The once-vacant building in the foreground was the home of a dry cleaning business. It was later converted into apartments. The upper floors, when added to the old building, blended into the existing foundation.

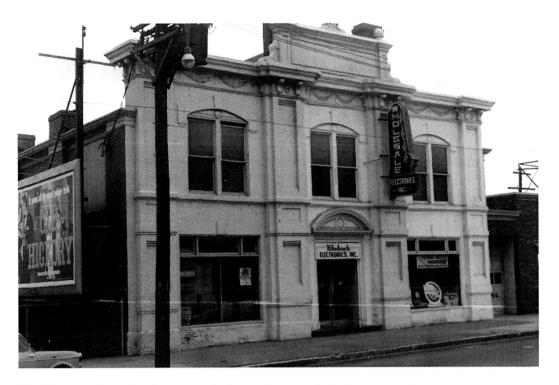

The Wholesale Electronics Company, a distributor of radio and television parts and vacuum tubes, was situated on the 800 block of Walnut Street. Previously, the business was located at two other city locations. *Photo courtesy of Norman Buckalew.*

Today, one of the two locations for Wholesale Electronics remains vacant and fenced off. Not too far from this site, however—and still standing—is the old livery for the city police force.

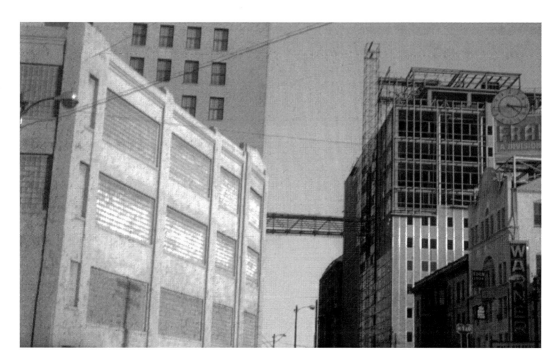

The Wilmington Trust building is under construction at 100 West Tenth Street around 1960. The pedestrian skywalk can be seen connecting to the DuPont Company's building. The Warner Theatre is on the immediate right.

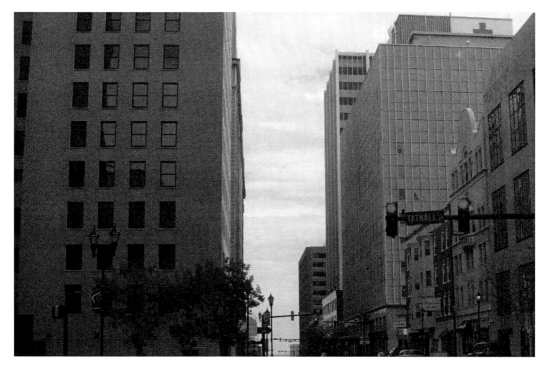

The Nemour's Annex building, viewed on the left in the previous photo, was later demolished. The pedestrian skywalk was removed in 1999 after Wilmington Trust sold the building that now is the Community Services building.

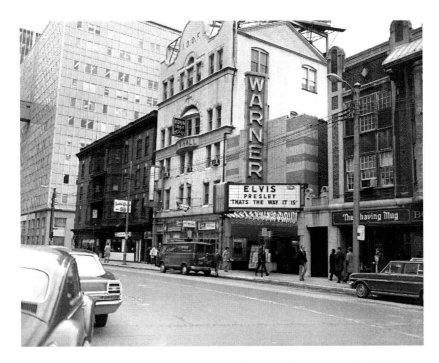

Here you can see the completed Wilmington Trust Building, and on the 200 block of Tenth Street is the Warner Theatre. This photo was taken around 1971. The skywalk is partially in view on the upper left. *Photo courtesy of Carman Panaro.*

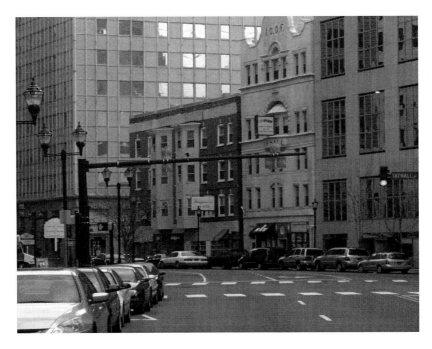

By the 1980s, Tenth Street, just before Delaware Avenue begins, started to change considerably. From where the Warner Theatre stood to the immediate corner, the buildings were demolished to make way for another bank building, the PNC Bank. Meanwhile, across the street, the DuPont Company constructed the Brandywine building in 1972 and sold it in 1999.

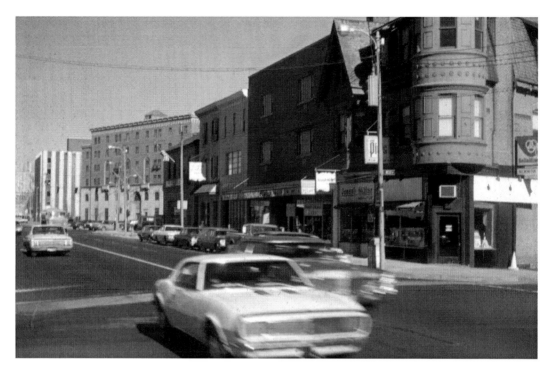

This photograph from 1969 shows the corner of Delaware Avenue and West Streets. The entire block was demolished around the time the DuPont Brandywine building was constructed directly across the street. At the far end of this small block is the city's Fire Station #1.

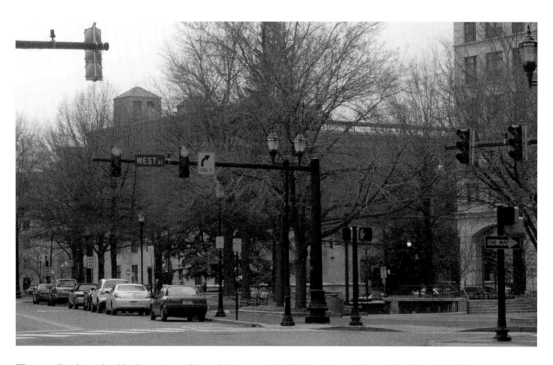

The small, triangular block was transformed into a park with benches and a garden fountain. Trees now block the view of the YMCA building in the background. The building on the right foreground is the new Wilmington Trust Bank building.

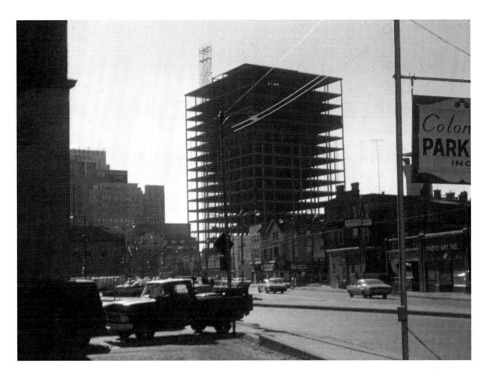

With the YMCA building on the immediate left, the PNC Bank building is under construction in 1970. From this vantage point, the completed building is barely visible in the next photo.

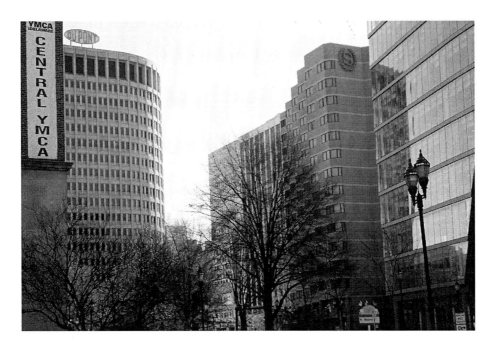

Today, the vicinity has changed so much that it is hardly recognizable from the previous photo. Four additional high-rise buildings were constructed between 1972 and today. The DuPont Brandywine Building is on the left, while on the right is a second PNC building, a motel and the new WSFS Bank building.

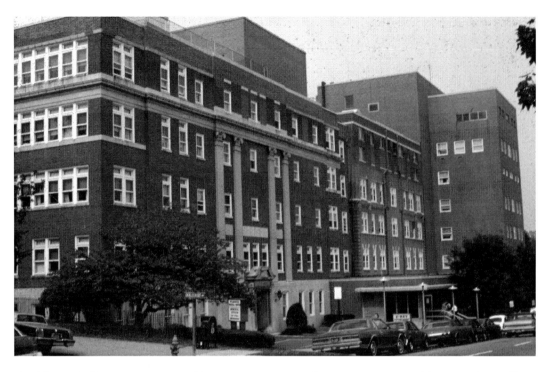

The Memorial Hospital, photographed in 1982, was located at Shallcross Avenue and Van Buren Street. The north side faced the Brandywine Creek. The hospital was demolished in 1985.

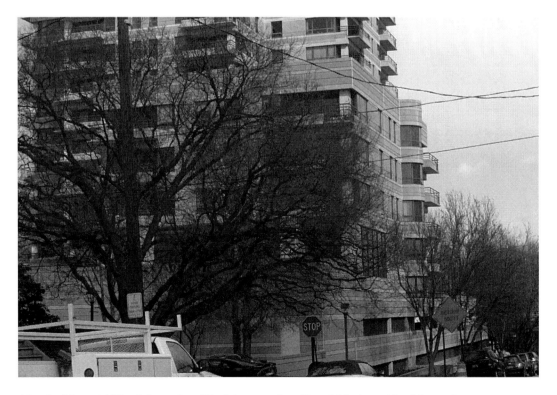

After the Memorial Hospital was demolished, it was replaced by a high-rise residential complex.

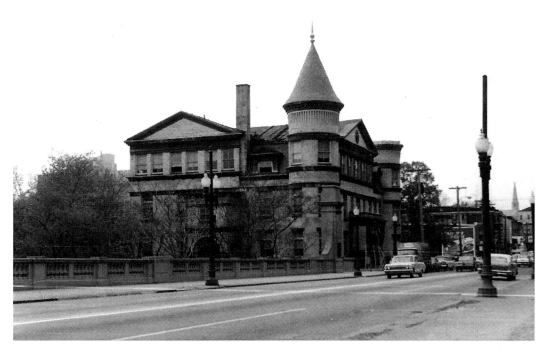

This building, pictured on many postcards, is Public School #24, constructed next to the Washington Street Bridge and across the street from the Delaware Hospital. *Photo courtesy of Norman Buckalew.*

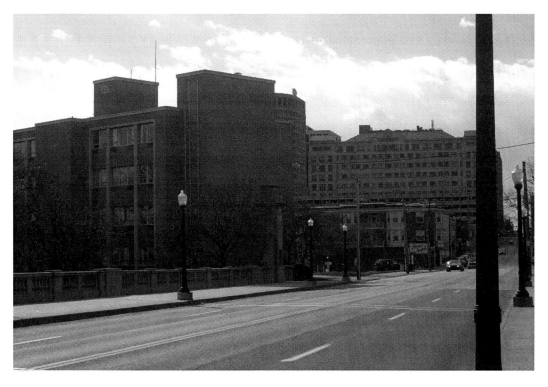

After it, too, fell into disrepair, the school was demolished to make way for a new building, which is part of the Christiana Care Hospital.

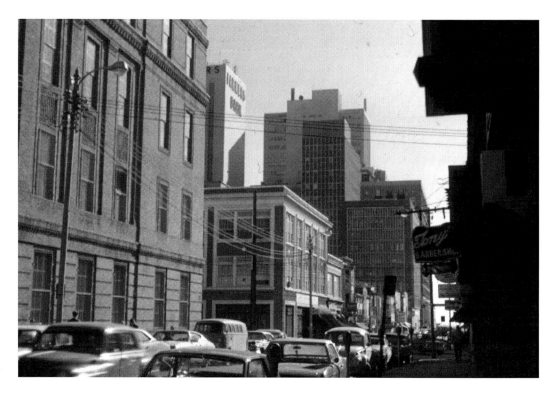

The Diamond State Telephone Company building, on the left, located on Ninth Street, was photographed in 1965. The building is now part of Verizon. In the distance are the Ninth and Market Street buildings.

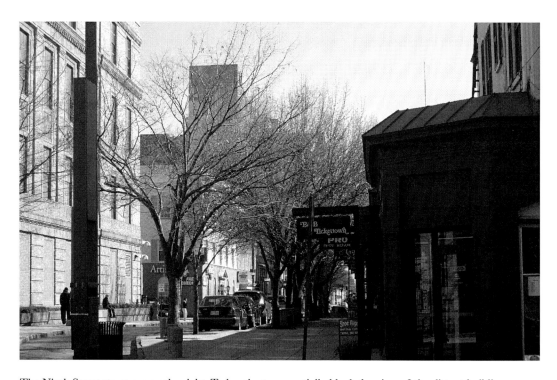

The Ninth Street stores are on the right. Today, the trees partially block the view of the distant buildings on Market Street, where the Delaware Trust tower is missing.

Moving toward French Street, by 1965, the vacant city blocks served as parking lots, waiting for construction to begin on the new buildings. Later, the new buildings would contain their own multilevel parking areas.

The same view today, looking north on French Street, is an indication of the amount of new construction that took place in the city. New buildings are on the left.

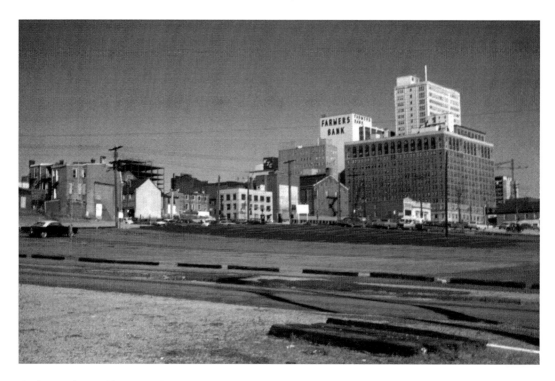

Again, another parking area where vacant businesses and houses once stood. In the distance is the Rodney Square area with what few high-rise buildings Wilmington had at the time. The large building on the right is the Delaware Trust building with the tower that was added in the 1970s.

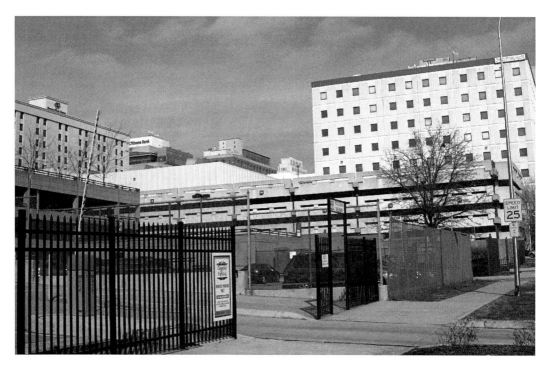

Today, the new construction all but hides the other buildings. Using the Delaware Trust building as a landmark, its roofline without the tower is visible in the center background.

This 1969 photo is looking north on King Street. On Saturday mornings, the local area farmers would back their trucks up to the curb to sell their meats, eggs and produce.

Government buildings and a utility business now occupy the parking lots. A small portion of the Delaware Trust building is visible on the left.

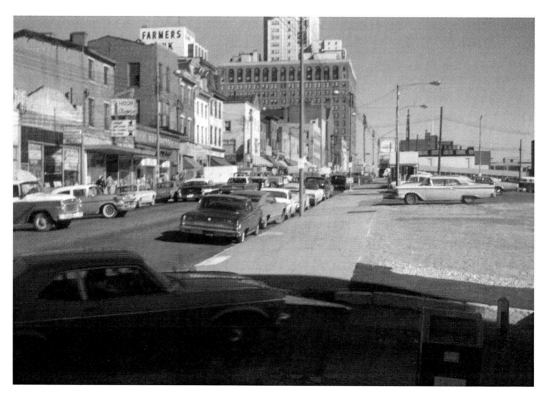

Farther down King Street, in 1984, we see another view of the vacant lots on the right. The familiar Delaware Trust building is in the background. The farmers are backed into the curb with their produce.

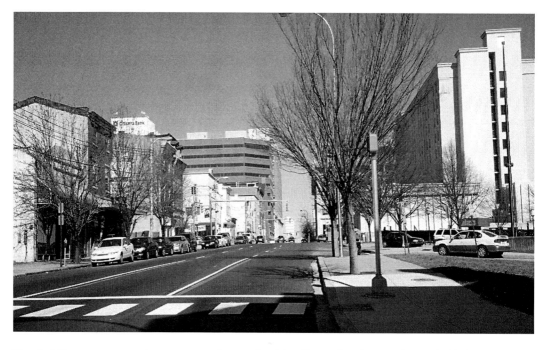

New buildings now occupy the once-vacant lots on the right. Comparing the two photos, the Delaware Trust building tower is a good example of "then" and "now."

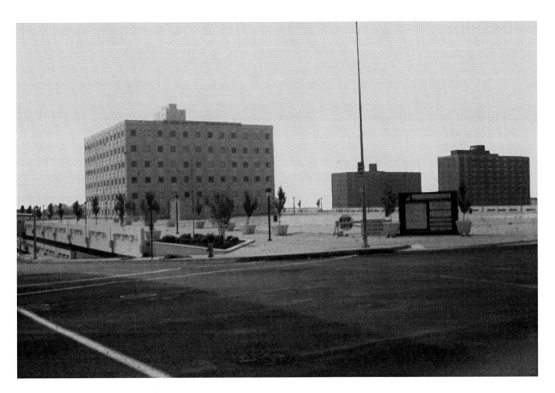

In 1977, the King Street Plaza was constructed at Eighth and King Streets with an underground parking garage. A new building would come later. The underground parking facility, as the sign indicates, is open.

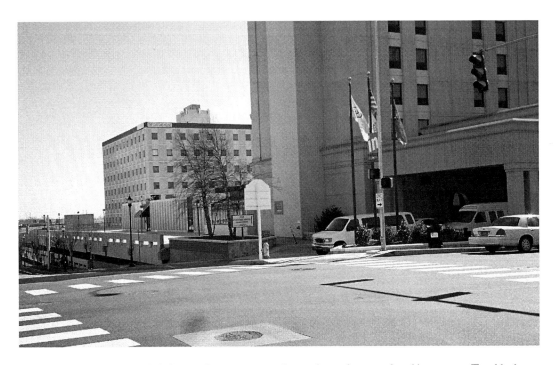

A few years later, a national chain motel was constructed over the underground parking garage. Two blocks to the north, south and east, the new government buildings and an insurance company were constructed.

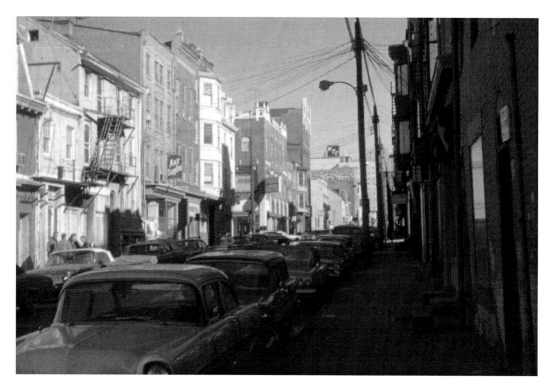

Traveling two blocks west and looking up Shipley Street from Fourth Street in this 1969 photo, the rooftop of the Wilmington Trust Bank building is seen in the distance.

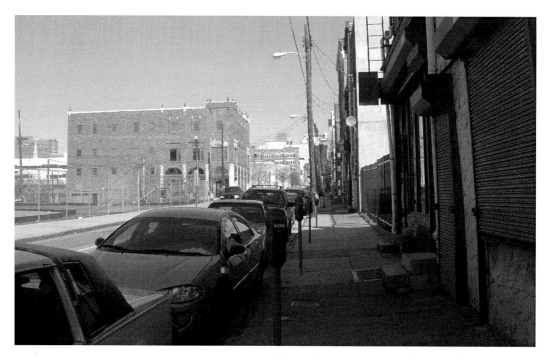

As we look north on Shipley Street today, most of the businesses were demolished, including well-known ones like Hardcastles Art Supply, Harting Sign Company, Brand Furniture Store and Knowles Music, Inc.

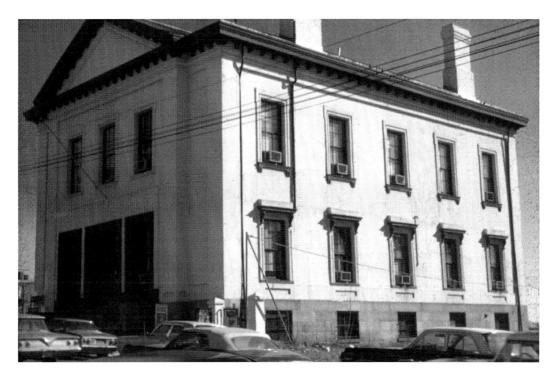

In 1969, the old Customs House building was all that remained on this city block at Sixth and King Streets. The Customs building will be remembered as the location where young men would go to enlist into the armed forces.

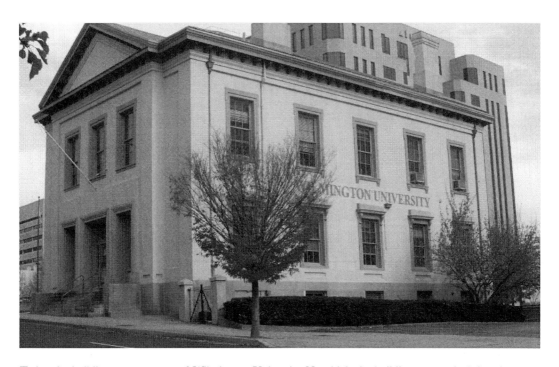

Today, the building serves as part of Wilmington University. New high-rise buildings are to the left and rear. In the area behind the old Customs House, four blocks of French Street were closed off to traffic, turning the eight square blocks into one complex that included a new courthouse.

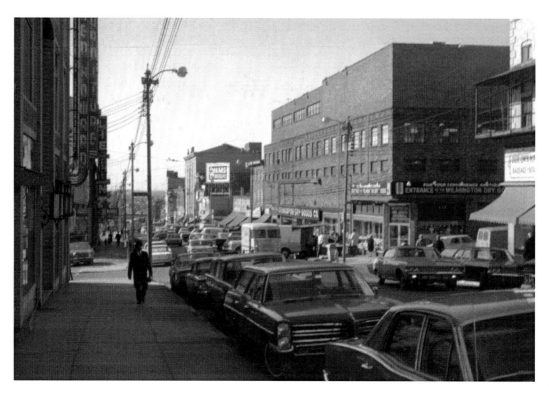

The rear of the Wilmington Dry Goods store stands at Fifth and King Streets. The distant billboard sign advertises Wilmington radio station WAMS, a once-popular rock-and-roll station. Ogden Howard Furniture and Liebman's Furniture Stores are on the left. The photo is dated 1969.

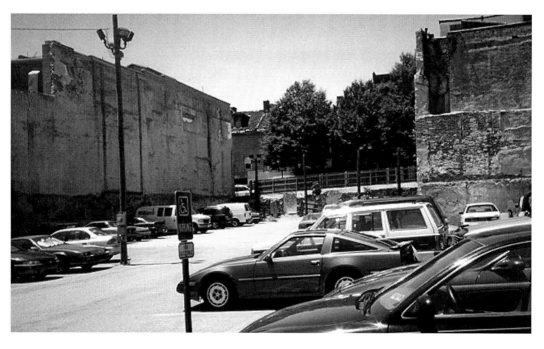

After the Wilmington Dry Goods store was demolished, the location operated as a parking lot for years. This view captures King Street up to what once were the store's front doors on Market Street.

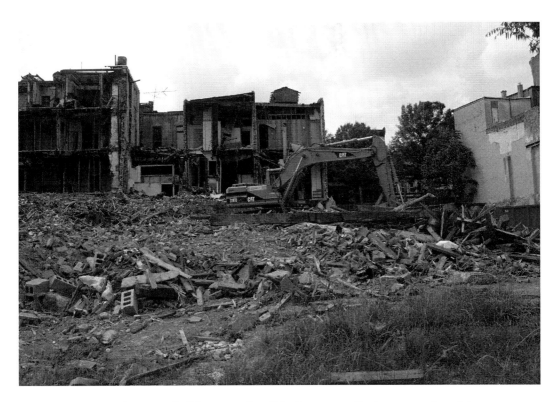

In 2006, the surrounding vacant buildings were demolished to prepare for the construction of the new Renaissance Centre. Looking at the trees in the distance, the front area of the old Dry Goods store on Market Street is still visible.

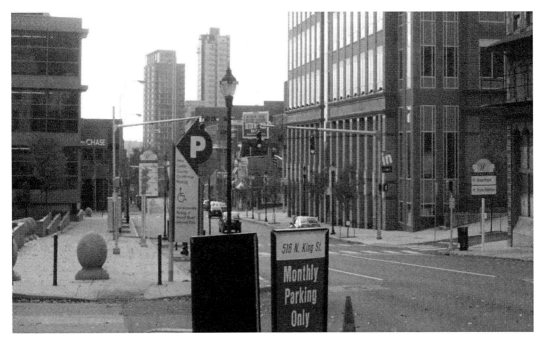

The new Renaissance Centre now occupies the site of the former Wilmington Dry Goods store. Looking farther south, in the distance, you can see the new high-rise apartment buildings in the Christina Landing area.

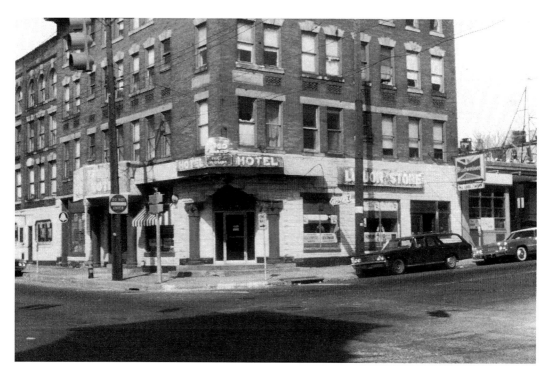

Moving farther down to Front and French Streets, we see the Terminal Hotel that was located directly across from the Wilmington's Pennsylvania Railroad station. A block away was the Short Lines bus terminal. *Photo courtesy of Norman Buckalew.*

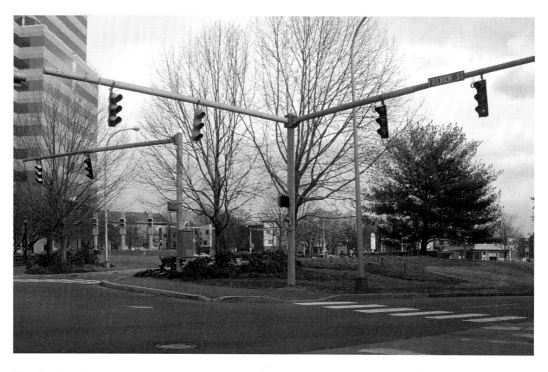

The Terminal Hotel, toward the end of its existence, became a somewhat seedy establishment. It was demolished and turned into a park as preparation for the new Bank One twin buildings.

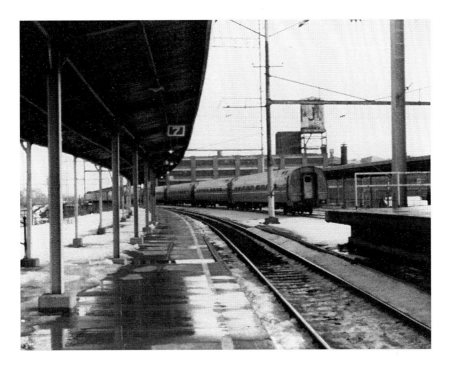

Across the street from the Terminal Hotel was the Wilmington facility for the then Pennsylvania Railroad Station. From the upper concourse, the water tower of the former shipbuilding company, Pusey & Jones, is observed in the background.

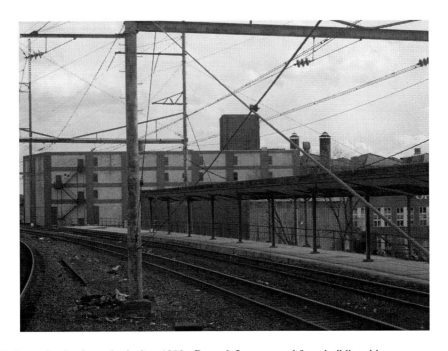

Before going bankrupt in the late 1950s, Pusey & Jones turned from building ships to fabricating papermaking machinery. Today, small machine shops and other light industries occupy the former manufacturing buildings.

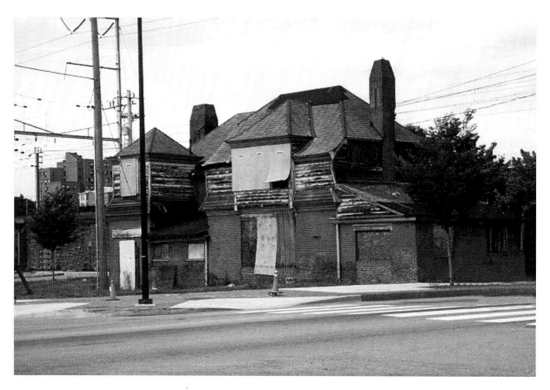

On the south side of the railroad is a vacant freight depot building. Neglected and rundown, the building sat unoccupied for many years.

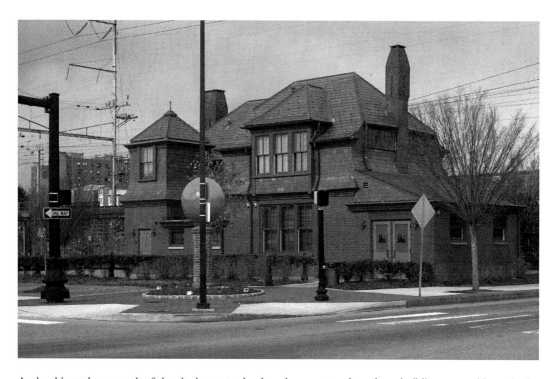

As the shipyard area south of the city began to develop, the vacant and rundown buildings were either raised or renovated. The old freight depot was purchased by ING Direct and was restored into offices.

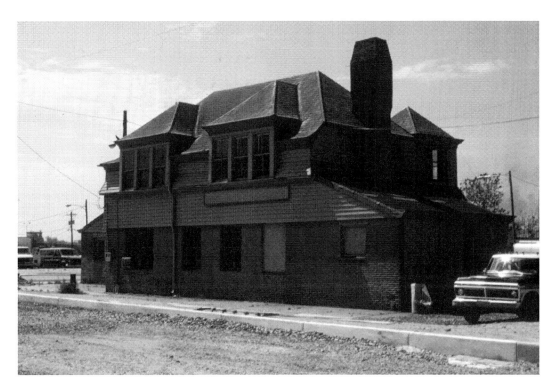

Another view of the old freight depot building photographed in 1984. Beyond this building lay the area where other shipbuilders and railroad car manufacturers once operated.

Downtown and Beyond

In this chapter, we travel to the surrounding areas from the center of Wilmington. Beginning with the Kennett and Concord Pikes, we will see the old patched tree and the Blue Ball Barn.

The Kennett Pike has remained the same since it received National Scenic Byway status. The one exception is the area just outside of the city limits, where a shopping center was renovated and expanded.

The Concord Pike is another story. Shopping centers are almost on top of each other along this route, stretching almost to the Pennsylvania state line. Two intersections just north of Interstate 95 were realigned and expanded.

We will visit the Kirkwood Highway and Broom Street where the old New Castle County Workhouse and the Wilmington General Hospital were located. Each of these facilities was demolished in the 1970s.

Traveling up to Thirtieth Street in north Wilmington, we will view photos of the old Wilmington Park, where the original Wilmington Blue Rocks played baseball.

Do you remember the Oberly Brick Company on Miller Road that was vacant for years? The Gaylord Discount Store took it over until the fire that happened there in 1971 forced its closing.

These are just a few of the then-and-now remembrances from beyond downtown.

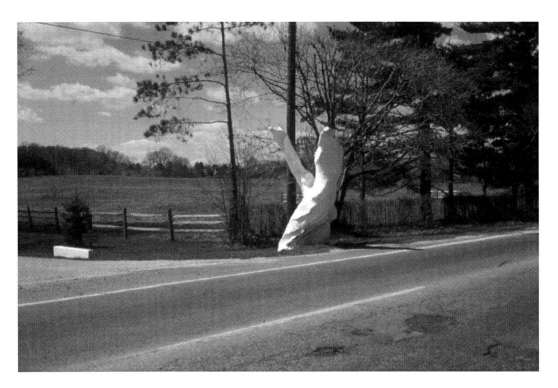

If you traveled the Kennett Pike, Route 52, out past the Twin Lakes in the 1950s and 1960s, you would see the two-hundred-year-old hard pear tree. Over the years, it was patched to prolong its life. Recent attempts to protect it with cement and plaster are picture here in 1979. It is said that George Washington once rested under this tree.

Age finally caught up with the old tree to a point where it crumbled. Today, an offspring of the old tree is growing and may one day see its 200th year.

In 1977, the old Blue Ball Dairy barn on the Concord Pike, Route 202, was left for ruin. It remained in a neglected state many years beyond this 1983 photo.

Beginning in 1999, the Blue Ball barn was rescued and restored to like-new condition. It is now the showpiece of a park, and the area has been turned into a historical area.

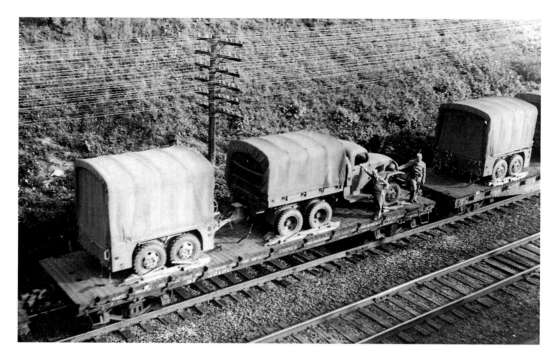

Wilmington at one time had two railroads with passenger and freight service—the Pennsylvania Railroad and the Baltimore and Ohio Railroad. In this 1941 photograph taken from the Fourth Street Bridge, a military train passes by with troops guarding the cargo. The B&O mainline had two sets of tracks then.

A view of the same location today overlooking the Fourth Street Bridge, it is not as busy as it was then, and one set of tracks was removed years ago along most of its length. The CSX line hauls only freight now. It is hard to believe that not too long ago, the B&O diesels with passenger service traveled those rails.

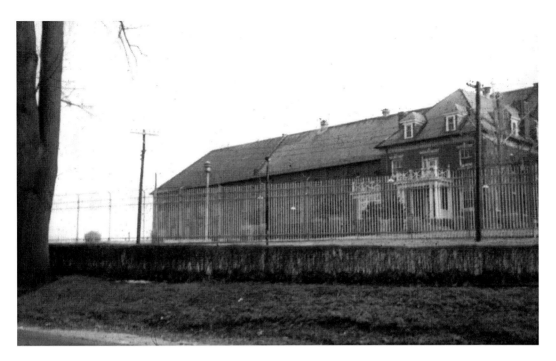

The New Castle County Workhouse, constructed in 1901, was located near Price's Corner. It operated as a functioning prison for New Castle County and, at times, for Kent and Sussex Counties. This 1971 photo captures one end of the main building around the time of its closing.

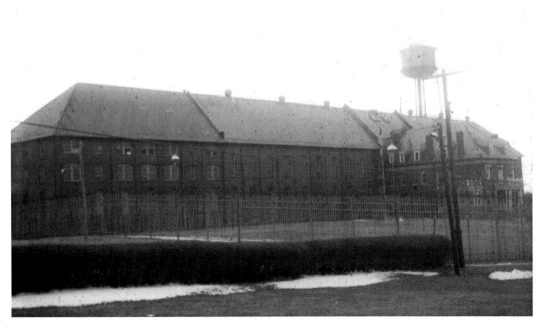

Another view of the same facility. The new Delaware State Police Troop #6 building was constructed on the grounds near the Kirkwood Highway in 1971.

In early 1971, this is how the main gate to the New Castle County workhouse appeared. The roof of a guard tower is visible to the left of the utility pole. The facility was demolished in March of that year and turned into a county park.

The site was converted into a county parkland with little league baseball fields. A single guard tower survived the demolition and is all that remains. The tower was restored and now stands vigilant over the county park.

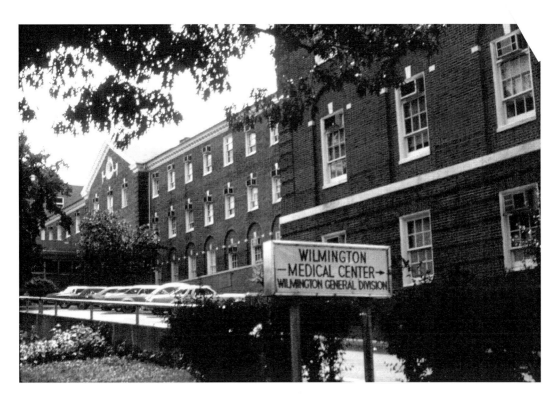

Another building that gave way to redevelopment was the Wilmington General Hospital located on Broom Street. When this photo was taken in 1983, the hospital was part of the Wilmington Medical Center.

When the new Christiana Care Hospital was constructed just south of the city, the Wilmington General Hospital was demolished. Construction of a new residential community soon followed on the site.

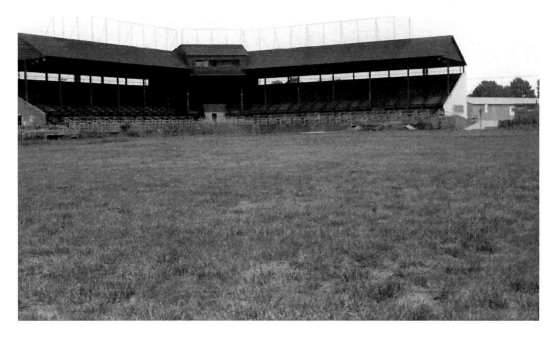

Out on Thirtieth Street and Governor Printz Boulevard was the Wilmington Park, where the original Wilmington Blue Rocks played. Major League Hall of Famer Robin Roberts played for the Blue Rocks as a minor leaguer. *Photo courtesy of Norman Buckalew.*

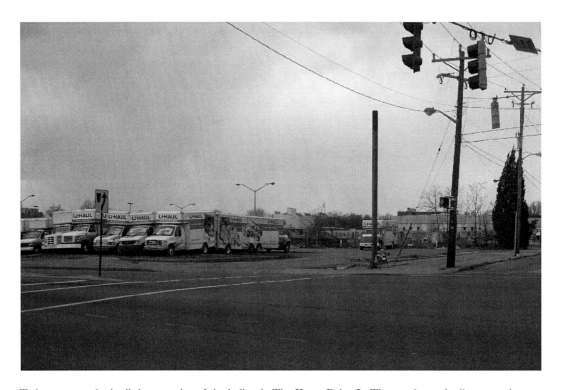

Today, a vacant lot is all that remains of the ballpark. The Kerry Drive-In Theatre, located adjacent to the park from 1951 to 1961, is also gone. The ballpark hosted the auto daredevil shows and other events, in addition to the local high school football games.

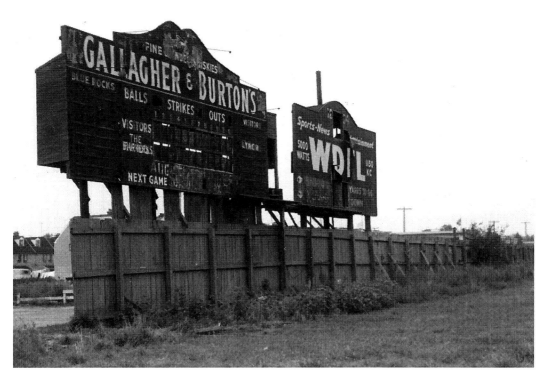

The scoreboard in the outfield, just barely able to support itself, lists the Blue Rocks as the home team. The other sign advertises the local radio station, WDEL. *Photo courtesy of Norman Buckalew.*

The remains of the grandstand. The park was later demolished. *Photo courtesy of Norman Buckalew.*

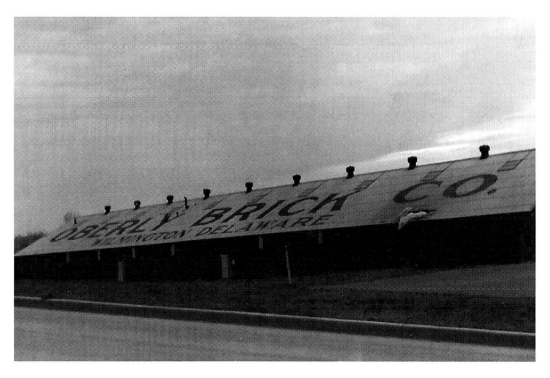

North of the city was the location of the Oberly Brick Company. This building was also vacated and left for ruin. In the 1960s, the Gaylord Department Store purchased the building and converted it into a discount shopping center. *Photo courtesy of Norman Buckalew.*

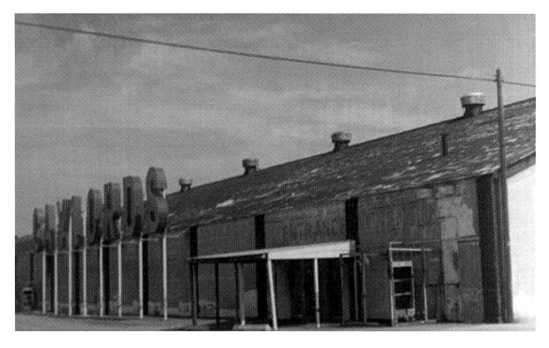

The site was located between Interstate 95 and the not-too-distant PS DuPont High School. In January 1971, a fire totally destroyed the store and the building was later demolished. *Photo courtesy of Rosemary Culver.*

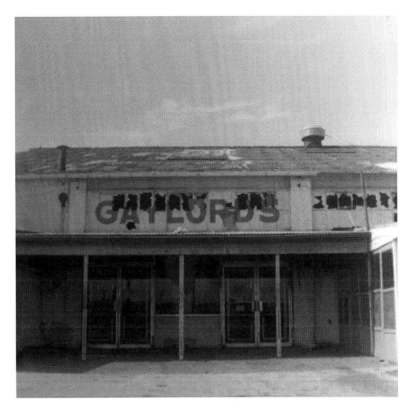

At the time of the fire, the store was the only building to occupy the site. This photo shows the front entrance on the day after the fire. *Photo courtesy of Rosemary Culver.*

Today, the surrounding location has been leveled and a new shopping center with a home improvement store now occupies the site.

WHY THE MAKEOVER?

After having seen the changes that took place over the past four or five decades, we ask the question, "Why the makeover?" Just looking around Wilmington and the surrounding area today, it becomes very apparent. The face of Wilmington was becoming old and worn. Many buildings were deteriorating, while others were no longer required or wanted. Products that were manufactured in the city because of the convenience of workers were relocated elsewhere as transportation methods expanded. Other industries vacated or dissolved because of advancing technology or processing requirements and restrictions. Exit the tanneries, shipbuilders, mills, dye works and heavy machine manufactures. The ruins of the buildings and sites sat for years and were left to deteriorate and either become homes for vagrants and vandals or fall prey to fires.

Housing also suffered in parts of the city—most noticeably, the east side of Market Street from French Street to the Brandywine Creek. In the late 1950s and early 1960s, the urban renewal project was getting underway. Whole city blocks of homes, apartments and mom and pop businesses were demolished, along with light industries and warehouses. The residents who held out had to live with the empty and shuttered buildings either across the street or next door. Eventually, everyone moved on to other locations. Even the empty lots that remained after the buildings were razed lay in waste for years.

The housing in the east side was developed in the late nineteenth and early twentieth centuries. Other neighborhoods to develop early were the ones located near the mills. After that, the population started to move west of Market Street. Business owners and the wealthy populated neighborhoods such as the Rockford Park area, Wawaset and those areas along Delaware and Pennsylvania Avenues. The housing in those sections were well kept and far enough away to not be affected by the industries mentioned above.

By the early 1900s, the immigrant population began growing and the neighborhoods created names for their themselves: Woodlawn Flats, Little Italy and Quaker Hill to name a few. The neighborhoods between the west side and the east side quickly filled in.

While some of the east side residents moved to the west side, those that remained were working-class blacks and immigrants who were the working force for the nearby industries, some of which later closed.

New housing was later constructed on the vacant lots and families began moving in. A few of the old streets were removed as some of the blocks were enlarged. New parks and schools were constructed as well.

This next group of photos will provide a representation of some of the housing in the east preceding the renewal period. Also included are photos from around the city to indicate other events and changes that have taken place recently, comparing them to the past. Several photos are from the late 1930s, while others will be of a more recognizable location. A few photos will provide a view into some current changes, while other photos will provide answers to questions like: "What ever happened to…?"

Opposite above: Walking down toward the east side, we pass this residential area on the corner of Tenth and French Streets. The buildings on this entire block were demolished and replaced with a bank building and a parking lot. This and the next several photos were taken in the late 1950s. *Photo courtesy of Norman Buckalew.*

Opposite below: Farther down east Tenth Street to the 700 block, we find brick row homes with arched entry doors. The houses along this section of Tenth Street were rehabilitated. *Photo courtesy of Norman Buckalew.*

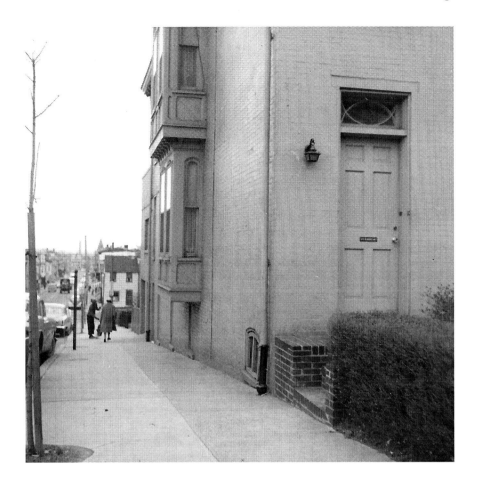

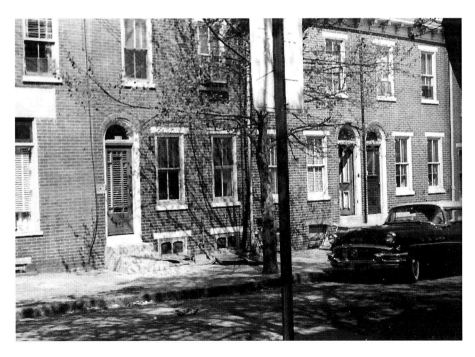

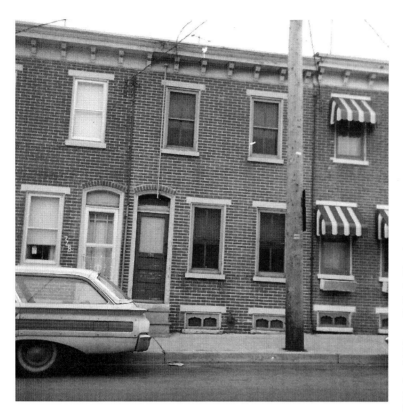

Left: In the middle of the 700 block, the two-story brick row homes continue, one with window planters and awnings. *Photo courtesy of Norman Buckalew.*

Below: Across the street is a house with a front porch. Tenth Street was one-way at the time, with room for parking on either side. *Photo courtesy of Norman Buckalew.*

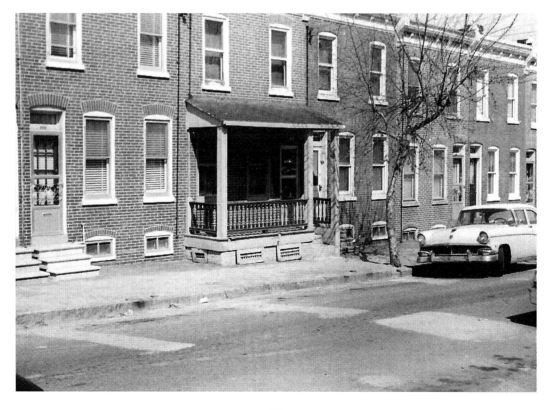

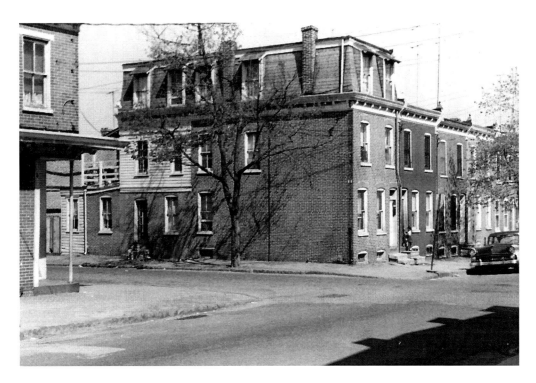

At the corner of Tenth and Bennett Streets is a residential building with a third floor. On every roof is the 1950s-style television antenna. *Photo courtesy of Norman Buckalew.*

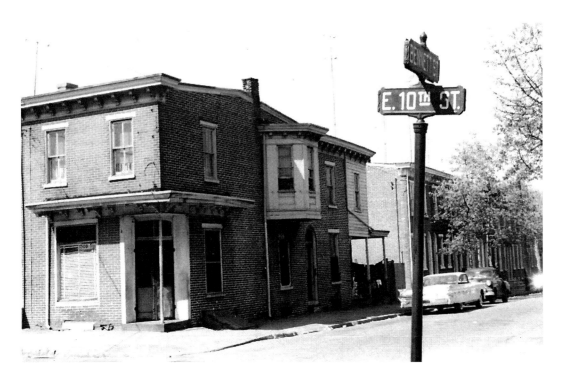

The street sign clearly indicates Tenth and Bennett Streets. The corner building with the second-floor bay window was the home of the Bennett Street Grocery Store. *Photo courtesy of Norman Buckalew.*

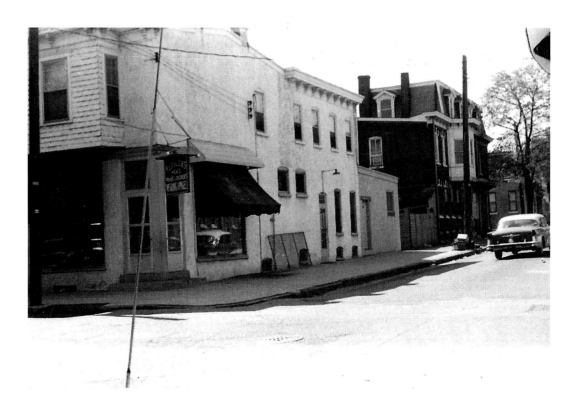

Above: On the opposite corner of Tenth and Bennett Streets was an apparel store. *Photo courtesy of Norman Buckalew.*

Left: This stucco-faced home is near the corner of Seventh and Spruce Streets. Just one block east, at Seventh and Church Streets, is the location of the Old Swedes Church, constructed in 1699. *Photo courtesy of Norman Buckalew.*

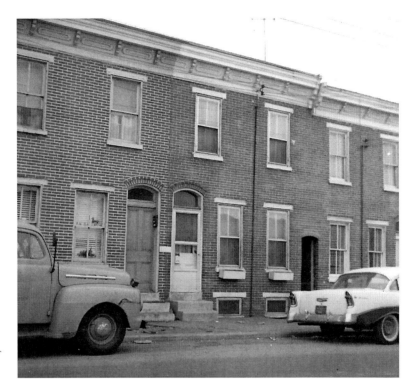

This section of brick row homes is located in the 1000 block of Church Street. The arched opening is an alleyway that leads to the rear of the homes. *Photo courtesy of Norman Buckalew.*

Norton's Junk Dealership occupied this location near Church and Taylor Streets. *Photo courtesy of Norman Buckalew.*

August's Fish Store was located on the corner of Church and Taylor Streets. This was one of the buildings to be demolished. The windows in this early 1950s photo are missing and the sign on the door may very well be a condemnation sign. *Photo courtesy of Norman Buckalew.*

A Sale sign is on this house, as the previous occupants have already moved. This is one example of a house that was not maintained. *Photo courtesy of Norman Buckalew.*

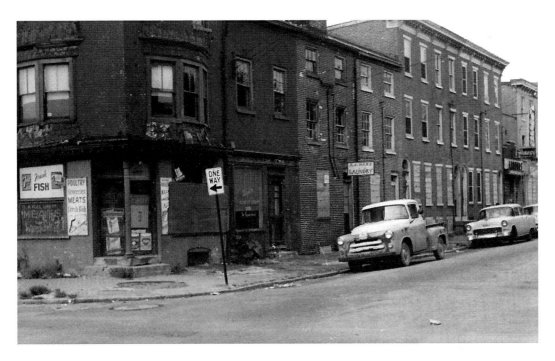

The Hirzel's Bakery at Ninth and Poplar Streets, shown here from the 1950s, was later demolished. *Photo courtesy of Norman Buckalew.*

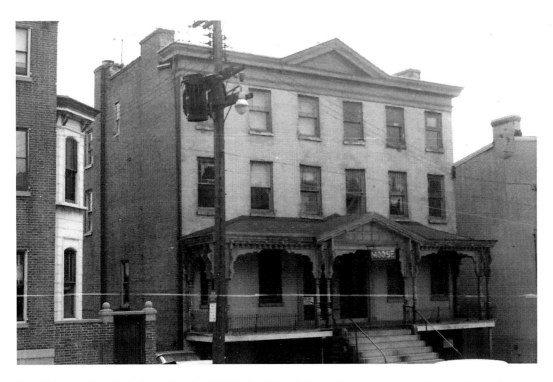

The Irish-American Hall, located in the 600 block of French Street, later was occupied by the Moose Lodge. This building was on one of the six city blocks that were demolished, and after the new construction, four blocks of French Street were closed off. *Photo courtesy of Norman Buckalew.*

Above: Another block of French Street, near Fifth Street, was the location of this public school building that was razed as part of the urban renewal project. *Photo courtesy of Norman Buckalew.*

Left: This one-block-long section of Decatur Street was flattened and done away with during the renewal project. *Photo courtesy of Norman Buckalew.*

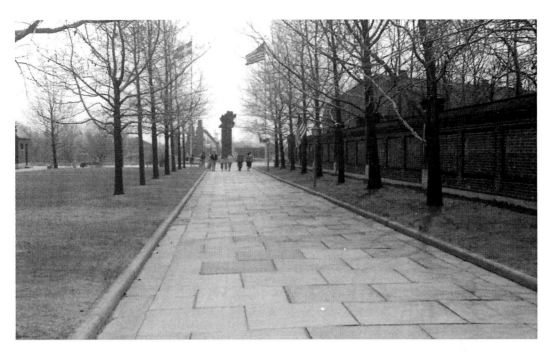

Christina Park in the 1950s . This long, tree-shaded walkway led visitors to the monument indicating where, in 1638, Captain Peter Minuit landed his Swedish ships. *Photo courtesy of Norman Buckalew.*

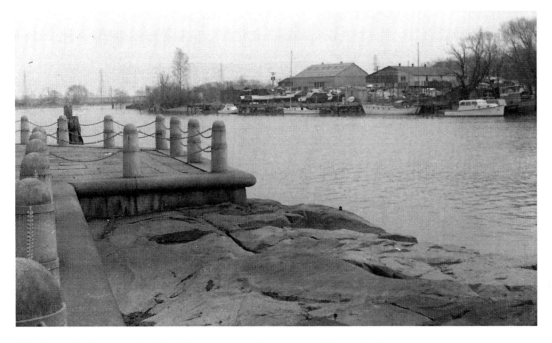

The "Rocks," where the Swedish ships set anchor. *Photo courtesy of Norman Buckalew.*

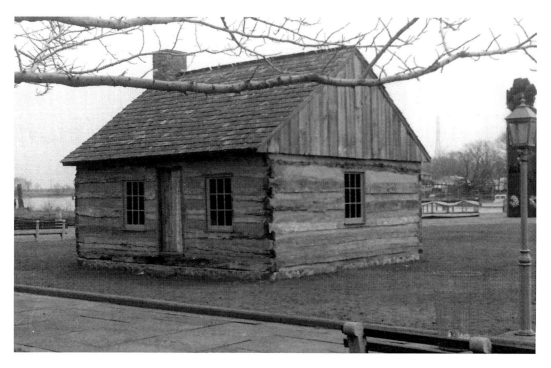

This log cabin, while not a part of the Swedish settlers site, was relocated here four decades ago to prevent its demolition at its original site near Prince's Corner. *Photo courtesy of Norman Buckalew.*

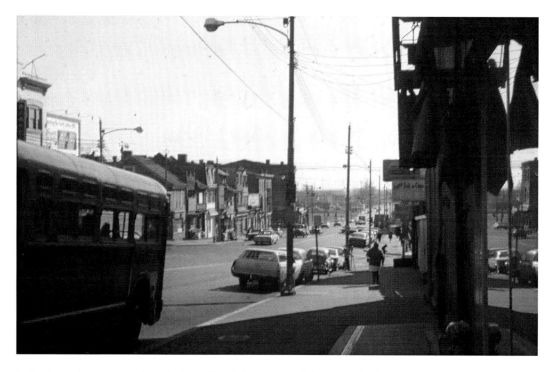

A city bus makes a stop as it heads down Fourth Street toward the east side. In the far distance are several vacant blocks that fell to the urban renewal project.

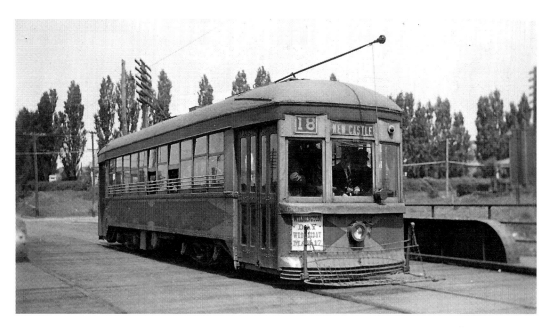

This 1939 photo captures a tracked trolley car crossing the Seventh Street Bridge over the B&O Railroad tracks. *Photo courtesy of Norman Buckalew.*

In 2004, this same bridge was closed to traffic because of safety concerns.

Barricades were set up on both the Sixth Street and Seventh Street Bridges over the railroad. Today, construction is continuing with completion set for 2008.

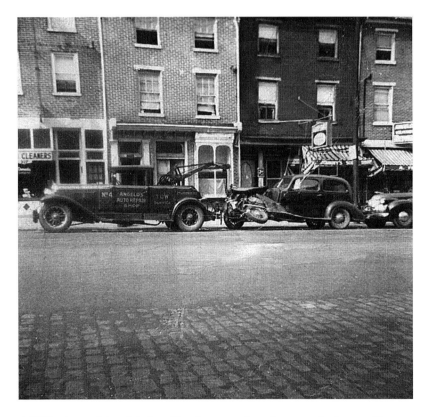

A 1940s photo of Angelo's Auto Repair tow truck towing a wrecked car on East Fourth Street. Note that Fourth Street still had cobblestones in place. *Photo courtesy of Spinazzola Family.*

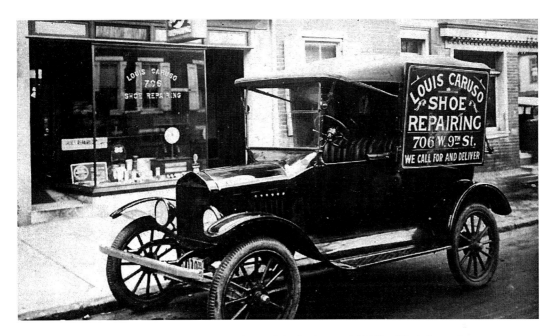

This photo of a show repair vehicle is parked in front of the business at 706 West Ninth Street. It was many small businesses like this that dotted the streets of Wilmington decades ago. *Photo courtesy of Norman Buckalew.*

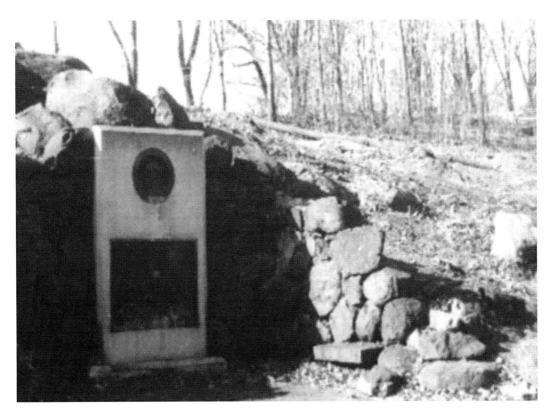

This is the original location of a monument dedicated to a military sergeant. It was in the path of the Adams–Jackson Street freeway (I-95). *Photo courtesy of Norman Buckalew.*

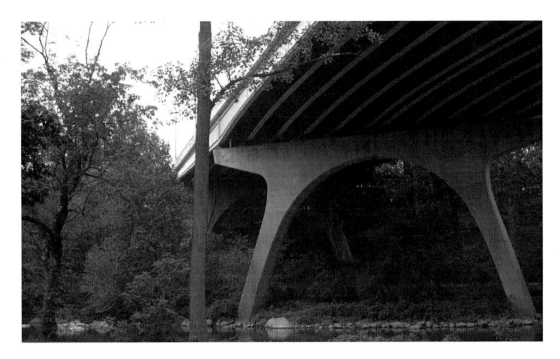

This is the I-95 bridge where it crosses the Brandywine Creek. The monument was located in the center of the photo on the southern side of the Brandywine.

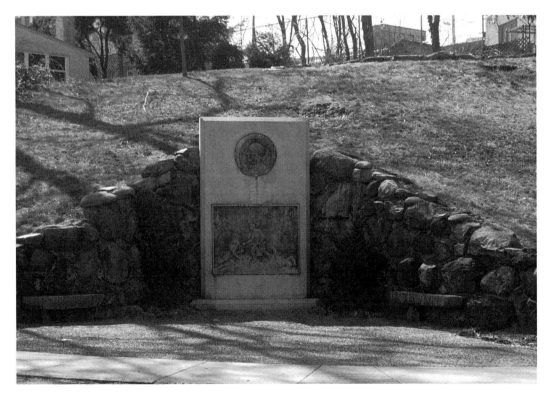

Here is where it sits today. The monument was removed before the bridge was completed and relocated to this new location a few blocks away.

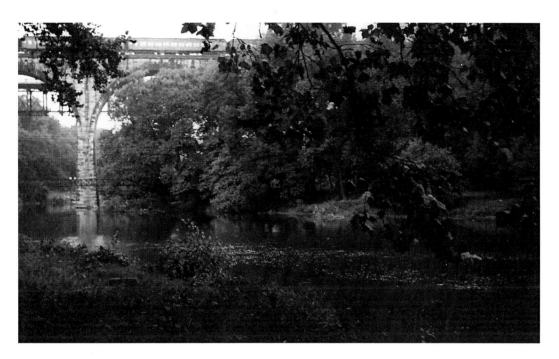

In the distance is the B&O Railroad Bridge where it crosses the Brandywine Creek. A passenger train is making its way across. *Photo courtesy of Norman Buckalew.*

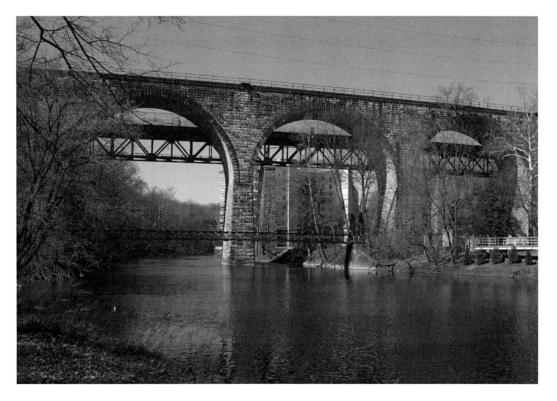

These are the same bridges today; however, B&O train service ended many years ago when it became the CSX.

Have you ever wondered what became of the city's drinking fountains and horse troughs?
Photo courtesy of Norman Buckalew.

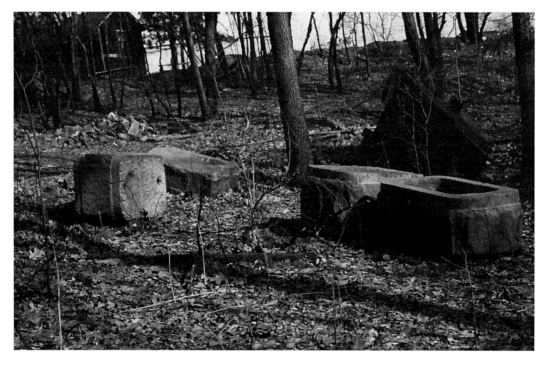

Here, the fountains are scattered around on a hill below the city's park maintenance area. *Photo courtesy of Norman Buckalew.*

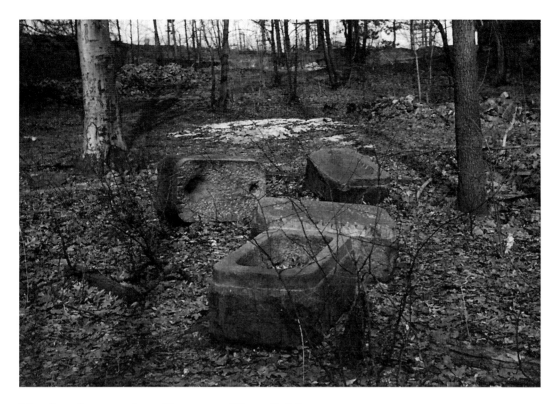

More fountains strewn about. *Photo courtesy of Norman Buckalew.*

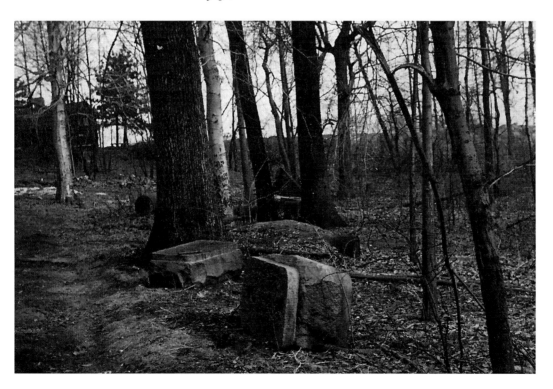

A view of a horse trough thrown among the drinking fountains. *Photo courtesy of Norman Buckalew.*

A final view of a horse trough. *Photo courtesy of Norman Buckalew.*

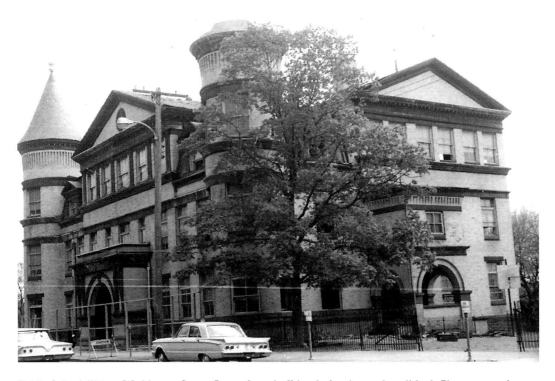

Public School #24 on Washington Street. It was fenced off just before it was demolished. *Photo courtesy of Norman Buckalew.*

Another school in the distance is the PS DuPont High School, located behind the Oberly Brick Yard. The Oberly Brick Company building was later converted into the Gaylord Discount Store, which was destroyed by a fire in the early 1970s. *Photo courtesy of Norman Buckalew.*

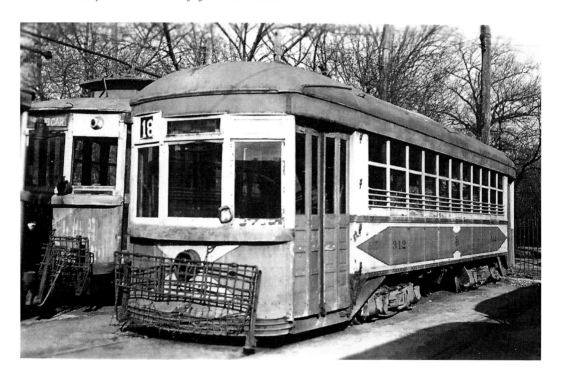

Tracked trolley cars provided service to the city through the 1930s. The two trolleys here are parked in the car yard on Delaware Avenue. *Photo courtesy of Norman Buckalew.*

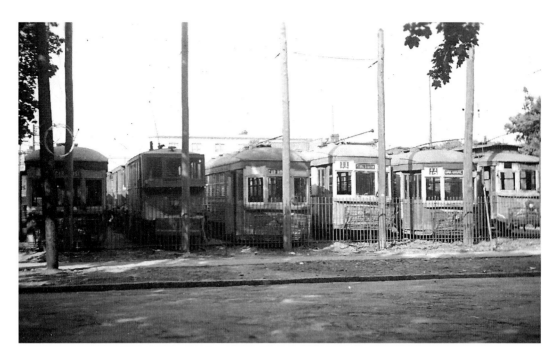

Other trolley cars are parked along the Clayton Street side of the car barn in this 1939 photo. *Photo courtesy of Norman Buckalew.*

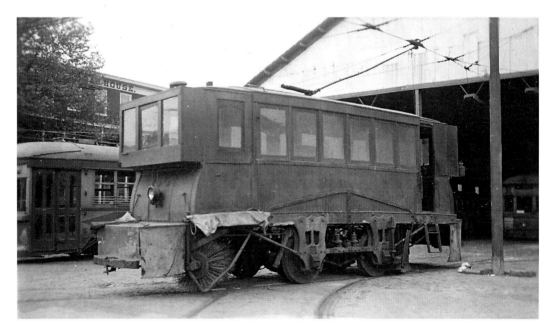

A sweeper car sits in front of the trolley car barn. In the distance is the Logan House Restaurant. *Photo courtesy of Norman Buckalew.*

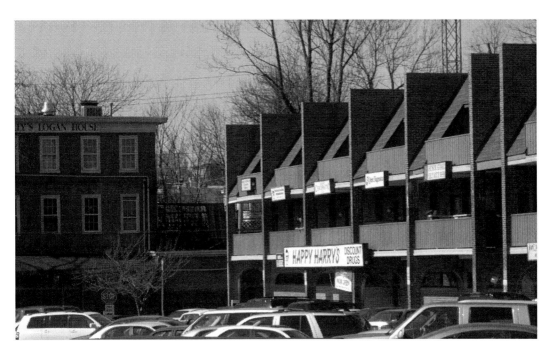

A view of the same location. The Logan House is in the background, but the trolley car barn was demolished decades ago and Trolley Square now occupies the site on Delaware Avenue.

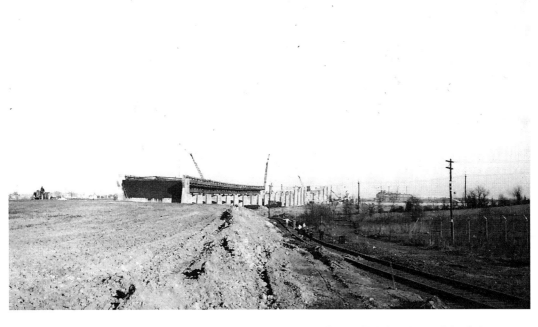

A view of the early construction phase of the Delaware Memorial Bridge. This is a photo of the Delaware approach near New Castle. *Photo courtesy of Norman Buckalew.*

This is a 1982 view of Mill Road. Operating as the Wilmington Piece Dye Company and earlier, Bancroft Mills. The company went bankrupt in 2003. Joseph Bancroft started the mill in 1831 and, up until the end, operated it as a textile finishing and manufacturing mill. Plans for the site include construction of condominiums.

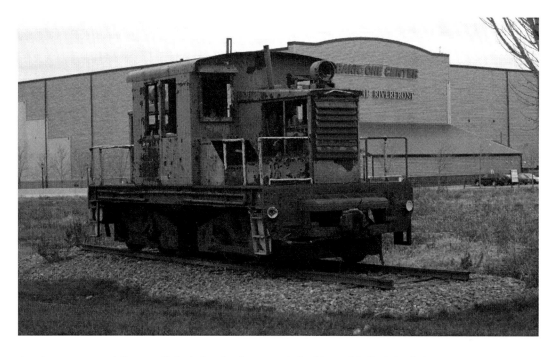

Another monument left to recall the industries that once thrived here, this "switcher" sits on a track section adjacent to the Riverwalk.

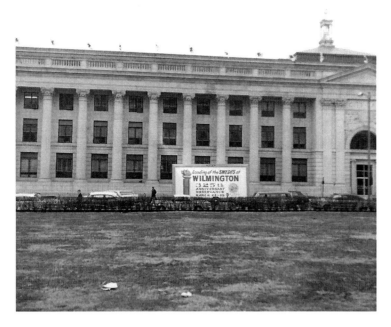

In 1963, the city of Wilmington celebrated the 325th anniversary of the landing of the Swedes. This sign is in front of Wilmington City Hall. *Photo courtesy of Norman Buckalew.*

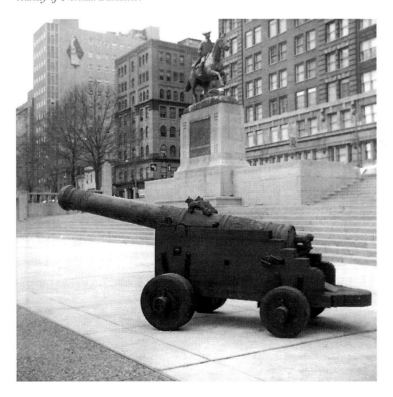

This cannon was placed in Rodney Square as part of the celebration. In the background is the Bank of Delaware building with its sign mounted on the side. *Photo courtesy of Norman Buckalew.*

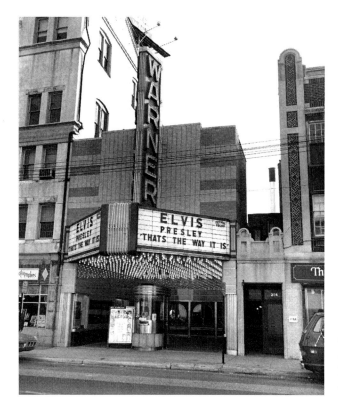

The Warner Theatre on Tenth Street, viewed in an earlier chapter, is shown here looking straight into the entrance doors. *Photo courtesy of Norman Buckalew.*

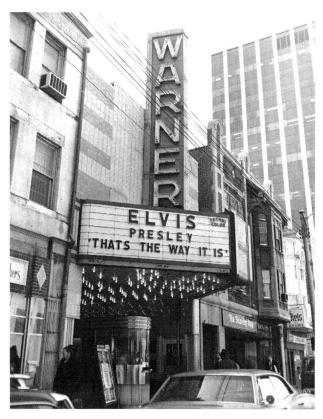

This view of the Warner Theatre looks from the east side with a new bank building in the background. *Photo courtesy of Norman Buckalew.*

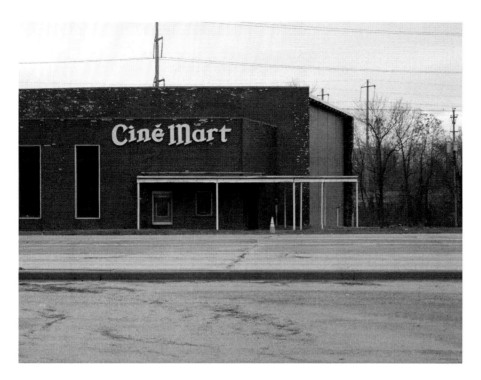

The Cine Mart, another movie theatre on the Governor Printz Boulevard north of the city, has been vacant for years. The theatre is located directly across from the former Merchandise Mart.

Photographed in 2006, this is the foundation for the movie screen for the Brandywine and later the Ellis Drive-In Theatre on the DuPont Highway. Today, a home improvement store occupies the site.

Hidden away near Sixteenth and Walnut Streets are the city's horse stables. From this 2007 picture, the stables are not in use, but they appear to be cared for.

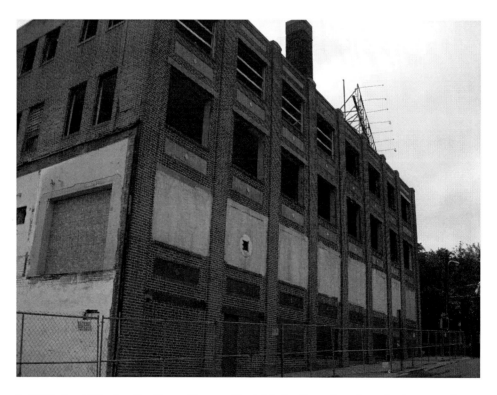

In 2007, the old Bordens Ice Cream Plant on North Market Street is under redevelopment after being closed for decades.

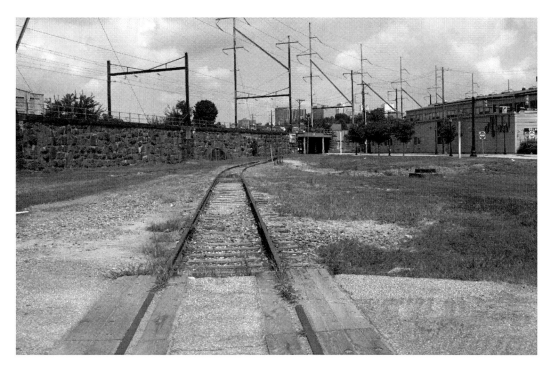

The abandoned railroad tracks here once carried materials to the industries located on the south side of Wilmington. This entire area has been under redevelopment for over ten years.

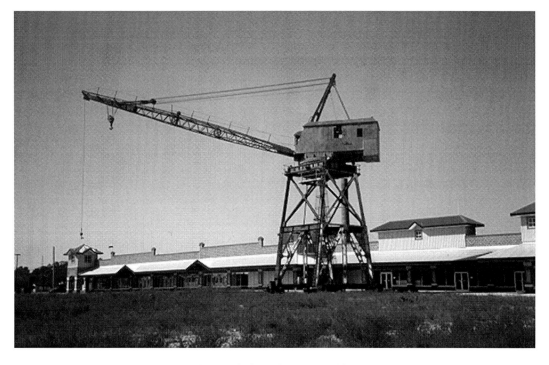

This crane is one of several that was left to remind us of the many ships that were constructed. The Riverwalk and stores are in the background.

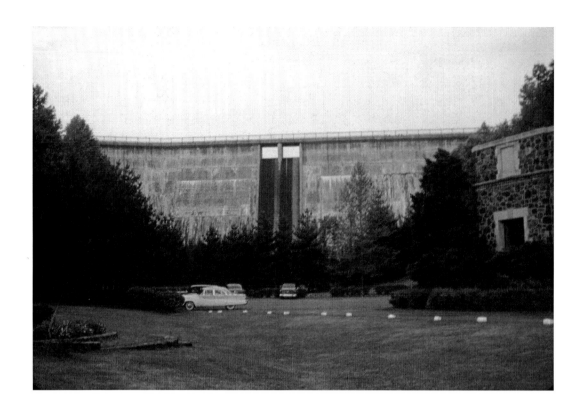

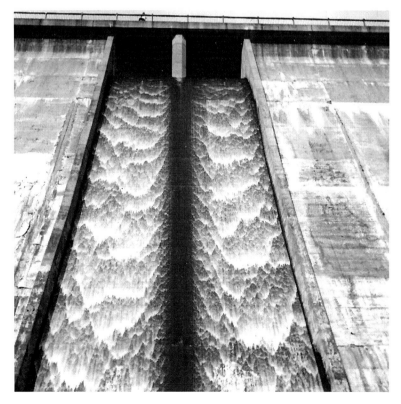

Above: Hoopes Dam pictured in 1956. Located outside of the western section of the city, the Hoopes Reservoir is part of Wilmington's water supply. Named for Edgar M. Hoopes Jr., the dam was constructed in the 1930s and has a capacity of two billion gallons.

Left: The Hoopes Reservoir, located in the outskirts of the city, provides water during drought periods. This is a view of the spillway from the bottom of the dam.

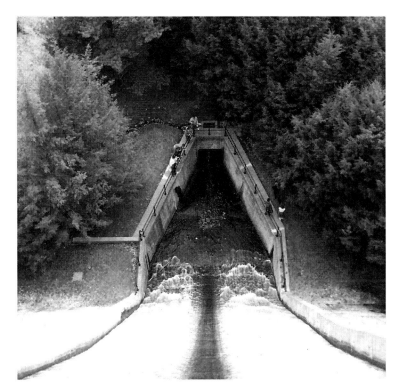

The Hoopes Reservoir area has been closed to the public since the early 1970s. At one time, visitors could walk a path to the top. This photo was taken looking down the spillway.

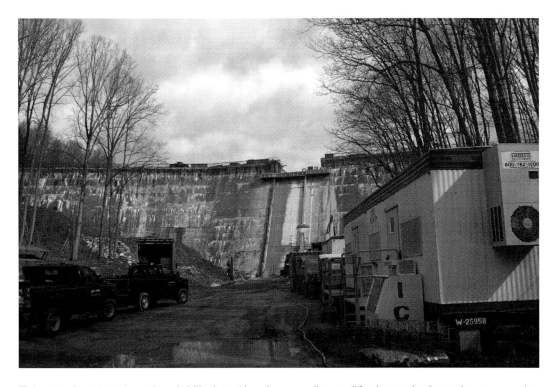

This photo from 2008 shows the rehabilitation taking place, as well as modifications to the dam to increase capacity.

WILMINGTON'S RENAISSANCE

The resurgence of Wilmington is taking place at what seems to be an expeditious pace. It is regularly reported that a developer has purchased a building or two to renovate into something different or new, or that some old building will be demolished for the construction of a new residential project.

At the southern end of the city, the city government wants to create a new commercial, residential and mixed-use area as part of the South Walnut Street urban renewal project, which will include a new street layout. The Delaware Avenue neighborhood area is under consideration for redevelopment as well.

Parts of Shipley Street may also be redeveloped. Market Street itself has not seen the end of the redevelopment. Developers have plans for the old Queen Movie Theater at Fifth and Market Streets to be converted into a new multiuse building. There are still plenty of vacant buildings to go around for a developer or two to formulate plans to help Wilmington make a comeback.

Another section of the city under consideration for improvement and development is the Seventh Street Peninsula, an area off of East Seventh Street where the Brandywine Creek travels over a mile in a circle and returns to within a little over two football fields of itself. One proposal for the peninsula is to develop it into a casino with associated restaurants, hotels and miscellaneous businesses. Currently located there are an industrial park and a private boat launch, in addition to a wooded area and marsh. If the plans come to fruition, this could possibly be the largest undertaking yet for the city.

On the edges of the city there are also redevelopment projects in the works. The old Bancroft Mill along the Brandywine Creek, which has been vacant, is in line for possible development as a residential complex.

Finally, we return to the section that started it all—the South Madison Street industrial and shipyard district. There are still plenty of vacant lots and wastelands that can be developed. In addition, the Christiana River and adjacent wetlands in the surrounding area may have significant preservation and conservation possibilities.

Admittedly, the redevelopment and improvement of the old, unoccupied Dravo Shipyard and the Madison Street industrial facilities of the leather tanneries and hosiery mills of yesterday played an important role in the revitalization of Wilmington, but that role is beyond the scope of this book. Also, privately held photographs of this locale are difficult

to find since it was a district to which only employees of the companies would venture. The general public basically stayed away from these sites.

We will finish our journey through Wilmington, revisiting some of the past, but mainly looking at what the city has become so far. There definitely are more buildings and skyscrapers. But there are far more changes taking place in Wilmington than can be covered here. There are also things that, so far, have been left untouched—perhaps to keep as a reminder of what was.

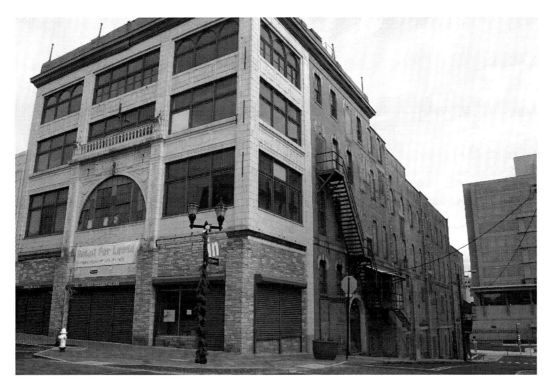

The sign on the front of the Queen Movie Theatre at 500 Market Street indicates that tenants are wanted as plans are currently underway to redevelop the decades-vacant movie house.

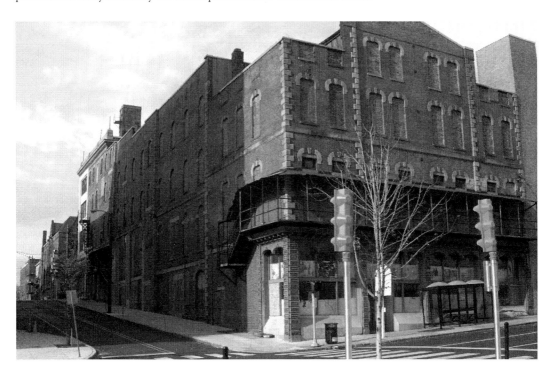

A view of the rear of the Queen Theatre at Fifth and King Streets. The fire escapes on the side of the building were removed years ago and the exit doors are padlocked.

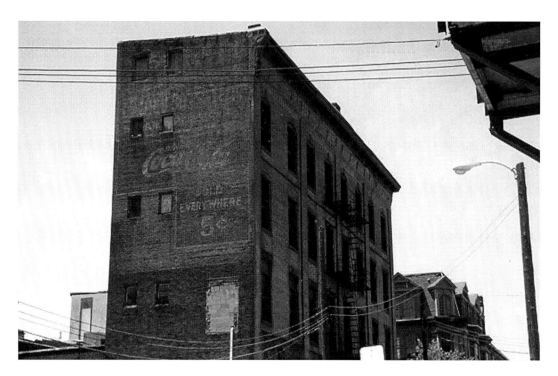

This building, situated on the corner of Fifth and Market Streets, stands alone in this photo after the surrounding buildings were demolished. The painted sign on the building advertises a soft drink for five cents.

Today, the new Renaissance Centre building joins with the old as it now occupies the site of the former Wilmington Dry Goods store.

The location of what was once the New York Restaurant, famous for its banana cream pies, will become part of the Renaissance Centre. The front façades will be saved as the buildings are renovated.

This photo shows how the front of what was the entrance to the Wilmington Dry Goods store looked in 2006. This site will also become part of the new Renaissance Centre.

This old storefront on the corner of Fourth and Market Streets will also become part of the Renaissance Centre as the old façades are blended into the new building.

The 300 block of Market Street today is also in the process of reconstruction. Again, an old building is undergoing repairs with a new high-rise bank building in the background.

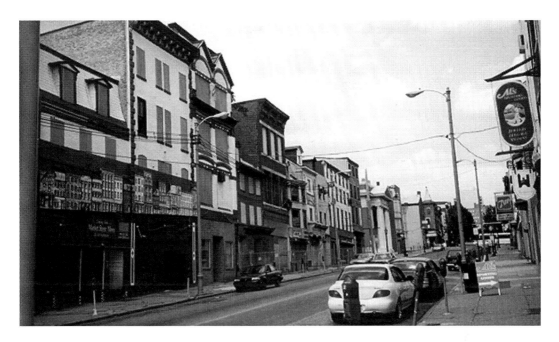

The entire three blocks on the west side of Market Street, where decades ago pawnshops and storage buildings were located. A new area called the Ships Tavern District will have new businesses and loft-style apartments here.

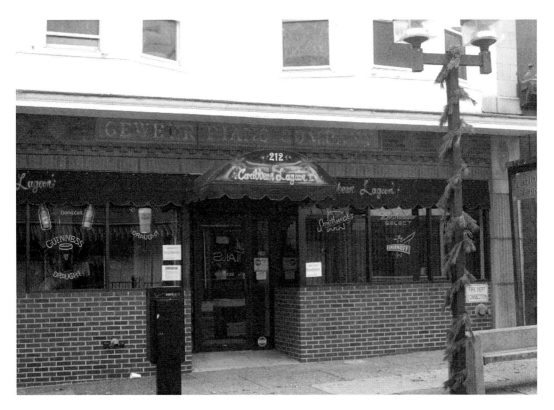

In other parts of the city, small changes also took place, such as the one-time Gewehr Piano Company on Ninth Street, its sign still visible above the door, that is now a restaurant and lounge.

In the north of the city, this building was once the home of the Penny Hill Donut Shop, with its favored cream donuts, to which customers would travel from all over the county to purchase a dozen.

Age and time have caught up to certain locations; they are no longer used, but are still present. This drinking fountain/horse-watering trough is in the Brandywine Park area.

This drinking fountain remains in the Rockford Park section of Wilmington. Many years ago, you would see the concrete fountains throughout the city.

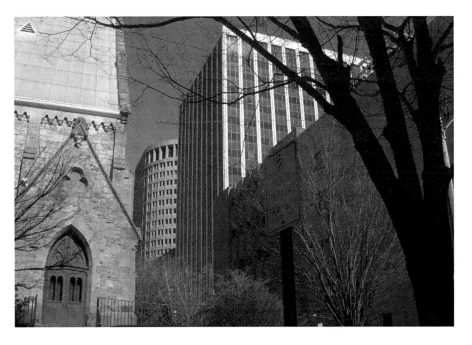

Still, traveling around Wilmington today, one sees many changes that took place over the past several decades, and there will be more to come. Some of the new construction stands alone, while at other settings, the old and new seem to meld together. At the corner of Ninth and West Streets, a church stands next to two high-rise buildings.

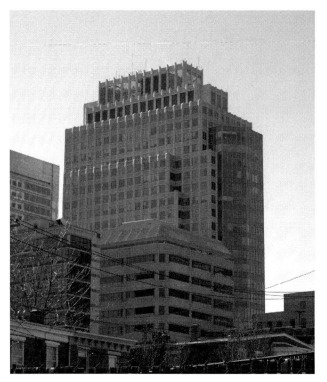

Left: The twenty-three-story Chase Manhattan Center, constructed in 1988, may be small to other cities, but it is the tallest in Wilmington to date and dwarfs the surrounding buildings.

Below: The glass side panels of the ING Direct building reflect the clouds as it stands tall behind a residential neighborhood.

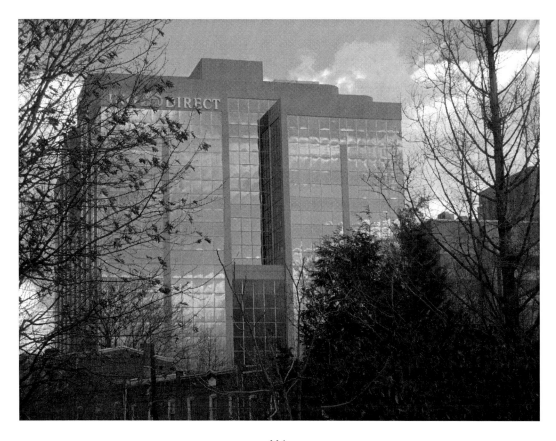

Delaware Avenue, in recent years, has not been left out as it, too, shows off the new buildings going up. The WSFS bank building, built in 2006, stands out prominently on Delaware Avenue.

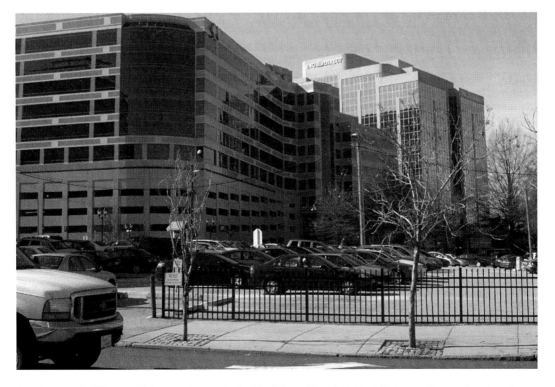

Another new building on Delaware Avenue is the Blue Cross/Blue Shield of Delaware. Its previous location was just several blocks away.

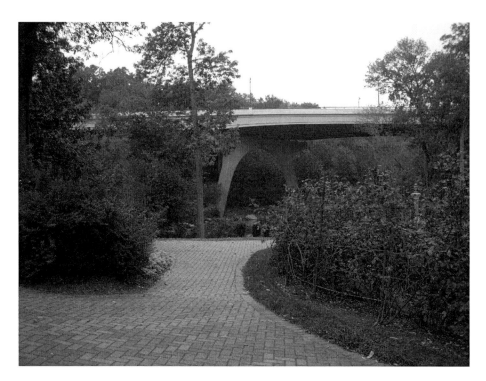

The Interstate 95 bridge over the Brandywine Creek blends in with the Rose Garden and the Brandywine Park below. Prior to the construction, there were concerns about its impact on the surrounding area.

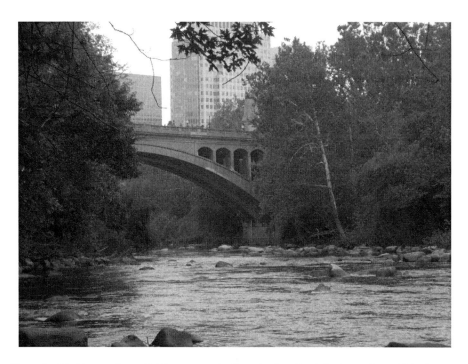

Here, the Washington Street Bridge crosses the Brandywine Creek in front of two high-rise buildings, demonstrating again the juxtaposition of the old with the new.

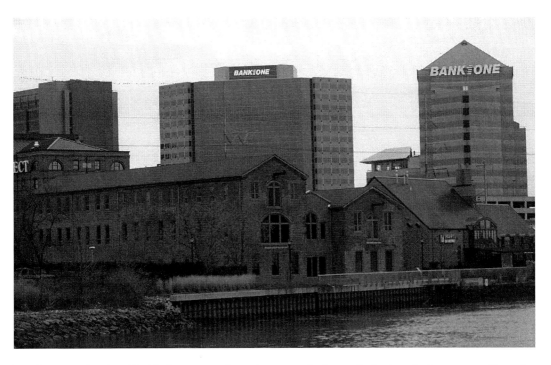

Finally, comparing the old with the new, we do not have to go back very far in time. In the area near Second and Walnut Streets, the Christina Center bank complex was constructed in 1988. The signage on top displays Bank One. In the foreground, old buildings from the industrial era have been renovated into an office complex, bank and a restaurant.

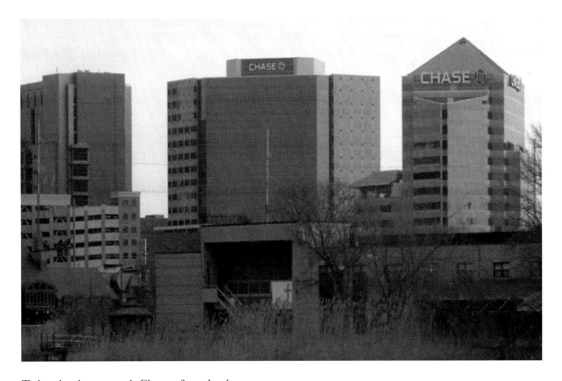

Today, the signage reads Chase, after a bank merge.

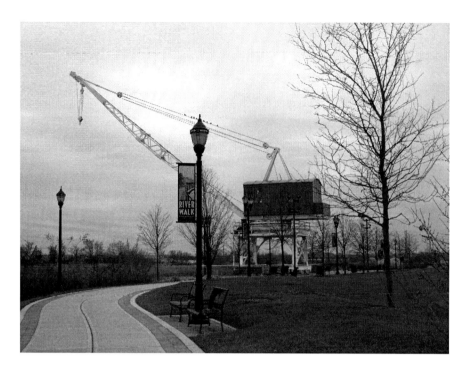

Not to be left out is the development of the heavy industrial area where the shipbuilders and railroad car manufacturers were located. This crane is one of many that were brightly painted and retained to remind us of the industrialized region that once hired workers from the various neighborhoods.

A light post with the Riverwalk banner welcoming visitors.

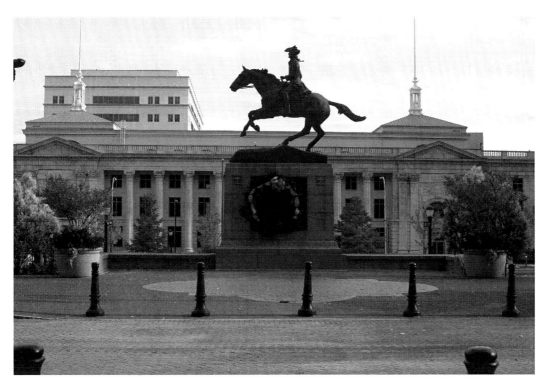

From Rodney Square, pictured here, and the surrounding blocks of redevelopment to the Riverfront and the Riverwalk, the city of Wilmington will continue to change and grow.

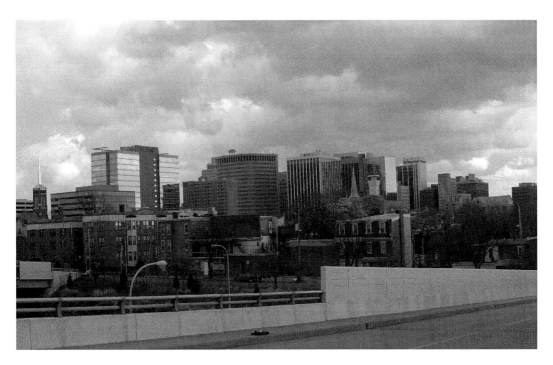

The Wilmington skyline in 2008 is no comparison to what it was five decades ago. To a long-ago Wilmington native, the city would be unrecognizable.

AFTERWORD

We have taken a journey through the city of Wilmington and beyond. Places and things that were once there are no more. Buildings have changed, streets have been realigned and businesses that once existed have all departed.

The construction and development continues to take place as new life is given to the many vacant buildings and empty lots on Market Street and the surrounding vicinity. High-rise buildings now dominate the streets of Wilmington.

New businesses are attempting to establish themselves as they attract customers. New ideas may have to be embraced. After all, Wilmington itself is trying out new ideas as it continues to attract residents and visitors.

Maybe, when it is all done, the charm that was once old Wilmington will return.

As we look at the Wilmington skyline on the preceding page, we might ask ourselves: Will it continue to change so that, one day, someone in the future will write a book using our "now" photos as their "then" images?

Market Street Businesses—1961

(From Front Street to Tenth Street)

Front Street Crosses

100 Paris Liquors

101 VACANT

102 VACANT

103 Thomas Paint & Paper

104 VACANT

106 Earl's Café

107 VACANT

108 Trade Upholstering Shop

109 VACANT

111 Jacobs Fuel Oil Service

112 VACANT

113 Metropolitan Home Equipment

114 VACANT

115 Sassone Billiards

116 Wilmington Locksmith Co.

117 Hudson Supply Co. Inc.

116 Joe's Hardware & Tools

118 VACANT

119 Jesse Auto Supply

123 Duffey's Cafe

124 Danforth Drug Store

125 Olympia Restaurant

126 Harris Pawn Broker

128 Standard Wallpaper & Paint

Second Street Crosses

200 L. Goldenberg Army & Navy Surplus

201 National Assoc. of Schools & Publish

202 Price Pawnbroker

203 Kenyon Inc. tobacco

204 Blue Rock Furniture

05 Park Hotel

205 National Liquor Store

206–208 Zimmerman's Clothing

207 Joyce Poter Dance Studio

209 Matthews Brothers Inc. office furniture

210 Al's Pawn Shop

212 Cooper's Home Furnishings

213 Wax Furniture Co.

214 Streamline Army & Navy Store

215 National Distributors

216 Capital Army & Navy Store

219 VACANT

221 Baylin's wholesale tobacco

222 Rialto Theater

223 Levy's Kumfort Shoe Store

224 Berger Brothers

225 Jack Coonin Wholesale

229 Stradley Jewelry

230 Topps Quality Shoes

233–237 Conner & Son leather goods

239 Apartments

THIRD STREET CROSSES

300 Horwitz Liquor Store

301 Farmers Bank of Delaware

302 Eppe's Army & Navy Store

304 Hiltex Clothes Shop

305 United Loan Office

306 Tom McAn Shoes

307 Gordon's Bar-B-Que

308 Eppe's clothing

309 Yours Truly Men's Shop

313 Cut-Rate Shoes Store

314 Leonard's men's clothing

316 VACANT

317 Rosbrow Inc. liquors

318 Samuel's Shoes

319 Wohlmuth Co. tailors

FOURTH STREET CROSSES

400 Economy Cigar Store

401 Oxford Pipe Shop

401 Concetta's Beauty Parlor

401 Bill's Clothes

402 Twentieth Century Grill

403 J.D. Jewelers

404 Sandborn Studio photographer

405 Jackie's Beauty Shop

404 Father & Son Shoes

405 Burton's Clothes

406 Alexander's children clothes

407 VACANT

408–410 NY Restaurant

409 Bankers Finance Corp.

411 Ralph's Army Navy & Sportswear Store

413 Roger's Jewelry & Optical Co.

414–420 Wilmington Dry Goods Co.

415 Butler's Inc. stationary

417 VACANT

419 VACANT

421 Levy's Loan Office

422 Lorains Shoe Inc.

423 Baynard's Optical Co.

424 Brait's Clothes

426 Sun Ray Drug Co.

FIFTH STREET CROSSES

500 Queen Theater

501 Harris Jewelers

503 VACANT

504 deLane Millinery

505 Artisans Savings Bank

506 F.W. Woolworth & Co.

507 The Fabric Shop

509 Crane's Clothes

510 VACANT

511 Leeds Men's Wear

512 Old Town Hall Building

513 Eckerd's of Wilmington drug store

514–516 J.T. Mullin & Sons clothing

515 Towne Theater

519 Bank of Delaware

SIXTH STREET CROSSES

600 Delaware Power & Light Co.

601 Kleitz Building

601 Fanny Farmer Candies

602 Hanover Shoe Co.

603 Beck Shoe Co.

604 Cannon Shoes

605 John's Bargain Store

606 Livingston's Credit Department Store

607 VACANT

608 Singer Sewing Machine Co

609 VACANT

610–612 HL Green Co. $0.05 to $1.00

611 S.S. Kresge Co. department store

614 Stern & Co. furniture

617–629 Kennards

SEVENTH STREET CROSSES

700–702 Arthur's Inc. women's clothes

701 Dress Bar

703 Reynolds Candy Co.

704–708 Braunstein's Inc. ladies' wear

705 W.T. Grant Co. department store

709 Dial Shoes

710 Bendheims shoes

711 Holiday Shoes

712 Joyce Shop women's wear

713 Peoples Credit Clothing Co.

715 Forsythe Shoes

716 Adams Clothes men's clothing

717 Federal Bake Shops Inc

718 Moskin's Credit Clothing Co.

719 Foley Brofsky Jewelry

720 VACANT

721 Famous Maid Shop

722–724 Brewer Bldg—Wilbur-Rogers Inc.

723 Eckerd's Drug Stores drugs

724 Apartments

725 Morris Square Deal Jewelry

726 Golden Dawn Hosiery Shops

728 Horn & Hardart deli

730 Richard-Donald Furs

EIGHTH STREET CROSSES

800 United Candy Co.

801–807 S.S. Kresge Co. department store

800 Gavatos Restaurant

802 Levitt Jewelry Co.

804 Braits men's clothing

806 Harold's Delaware Discount House

808 Lowe's Aldine Theater

809 Brofsky jewelry

810 Famous Maid Shop

811 Kleitz Building

811 Miles Shoes, Apartments

812 Crockery Den

813 Harris & Groll Inc.

814 Jewel Box

815 Loft Candy Shop

816 Milady Hat Shop

817 Presto Restaurant

818 Grand Opera House

819 VACANT

820 Shuster's Inc. men's clothing

821 York Store

822 West's Youth Center children's wear

823 Robert's Beauty Shop, Apartments

824 Richard's Inc. ladies' wear

825 Victor Bacon gifts

826 Central Restaurant

827 Linen Mart

828 Joy Hosiery Shop

828½ Tote-A Treat Co.

830 Children's Corner

832 Acousticon-Neumeyer Co.

834 Carl Cobin Shoes

836 Rosenbaum's toys

838 Wilmington Savings Fund Society

829 VACANT

831 Millard F. Davis Inc. jewelers

833 Flagg Brothers Shoes, Apartments

835 Ellison's gift shop

837 Kent Hotel

839–847 F.W. Woolworth $0.05 to $1.00 store

Ninth Street Crosses

900 Delaware Trust Co.

910 Hercules Building

912 Hunter Cafeteria

901 Bank of Delaware Building

911 Wright & Simon Inc.

913 English Grill

919 George Hanby Co.—Various Offices

921 Storm's Shoes

923 Louis Redding lawyer

925 United Cigar Store

925-927 North American Building

927 United Cigar Whelan Stores

Tenth Street Crosses

About the Author

Harry Rogerson was born and raised in Wilmington, where his family lived in the Woodlawn Flats. He attended the Charles. B. Lore School until his family moved to the Elsmere area. After graduating from Henry C. Conrad High School, he worked for a year at the Wilmington Dry Goods Company on Market Street as a salesperson. There he met his future wife. After serving three years in the U.S. Army as a missile specialist—including thirteen months in South Korea—he began working for the E.I. DuPont Company, retiring in 1991 from his position as a quality assurance specialist. During that time, he also acquired an associate's degree in computers from the RCA Technical Institute. Upon retiring, he became a life member of the VFW and also provided computer services to local political candidates.

In 1999, after attending a reunion for the children who grew up in the Wilmington neighborhood Woodlawn Flats, an idea of creating a website came to mind. After eliminating a number of potential website names, "oldwilmington.net" was selected. Almost nine years later, the website's visitors have both enjoyed and praised the photographs and nostalgic topics that have been presented for viewing.